IMAGES
of America

MILTON

ON THE COVER: In the late 1800s, Milton had a number of hotels. Pictured on the cover is the Glenwood, operated by George Skeels (far left). The Glenwood was located on Upper Main Street, not far from the railroad tracks. It was first built in 1879 by A.N. Austin and was originally called the Austin House. Charles Skeels later owned and operated Skeels Hotel near the bridge over the Lamoille River. (Courtesy of the Milton Historical Society.)

IMAGES
of America

MILTON

Gary Furlong

ARCADIA
PUBLISHING

Published by Arcadia Publishing
Charleston, South Carolina

Printed in the United States of America

Library of Congress Control Number: 2012946963

For all general information, please contact Arcadia Publishing:
Telephone 843-853-2070
Fax 843-853-0044
E-mail sales@arcadiapublishing.com
For customer service and orders:
Toll-Free 1-888-313-2665

Visit us on the Internet at www.arcadiapublishing.com

To my wife, Anne, for her constant support and her dedication to improving the lives of the young people of Milton through education

CONTENTS

ACKNOWLEDGMENTS

A work like this owes its completion to many people.

I thank Milton High School alumnae Caitlin Blake of Connecticut College and Kaitlyn Hansen of Clark University for their enthusiasm for history and this project. I also thank Milton High School students Courtney Racicot, Holly Thayer, Phil Patry, and Ryan Nichols for examining photographs, finding answers to questions, and compiling research.

Special thanks go to the many members of the Milton Historical Society, past and present, who have donated their time, energy, and photographs to keeping the history of Milton alive. Special thanks go to Bill Kaigle, Allison Belisle, Jim Ballard, and Rick Stowell for encouraging this project and providing support whenever needed. A special mention should be made for Lorinda Henry, whose work maintaining, organizing, and improving the collection of the Milton Historical Museum makes projects like this possible.

I hope that this book may inspire historic photographs in private hands to be donated as gifts to public archives and museum collections.

I also relied on various sources to help with the creation of this book, including *Look Around Colchester and Milton, Vermont*, edited by Lillian Baker Carlisle, and *Milton's Story*, published by the Milton Bicentennial Committee and edited by Ann Clark.

For guiding me through the process of preparing a book for publication, I wish to thank Rebekah Collinsworth of Arcadia Publishing.

Unless otherwise noted, all images appear courtesy of the Milton Historical Society.

INTRODUCTION

Long before settlers arrived from eastern and southern New England, Milton was a popular Indian camping ground. Located on the shores of Lake Champlain in the northwestern part of Vermont, Indians found the Lamoille River, which runs through the town, ideal for fishing.

In 1609, Samuel de Champlain became the first European to navigate the Lamoille River. It is commonly thought that around its mouth he spotted numerous mews, or gulls, and accordingly named the river la Mouette. It became the Lamoille when a map engraver failed to cross the t's.

It might be fair to say that Milton (and possibly Vermont as a whole) would not have been formed as we know it without Gov. Benning Wentworth. He was appointed the first royal governor of New Hampshire in 1741 and, within 10 years, began granting (selling) land to speculators in what is now Vermont (while keeping some land in each town for himself). The charter for Milton, which encompassed more than 23,000 acres, was signed by Wentworth on June 8, 1763. Many nearby towns, including Westford, Georgia, Colchester, and Essex, received their charters in the same year.

Settlement did not occur immediately, although it was encouraged to increase the value of the land. William Irish, Leonard Owen, Amos Mansfield, Absalom Taylor, and Thomas Dewey first settled Milton in early 1782. A record exists of what is believed to be the first meeting for the allotment of land to the town's settlers. The meeting took place in Middletown, Rutland County, on August 2, 1786. By the first census of 1791, the town had a population of 282. Milton saw much development during the early years, and the cutting and preparing of pine timber for market was the primary commercial activity. In the early years, much of the lumber was floated north to Canada through the waters of Lake Champlain. From there, it made its way to England, where it was mostly used in the production of ships' masts. When the Champlain Canal was completed, the market for timber shifted to New York. The cutting of timber caused forests to disappear, and more people began to farm on the cleared land.

The Lamoille River, which winds through Milton with seven waterfalls, provided the power for mills. One of the earliest developers of mills was Judge Noah Smith. Before 1805, he built two sawmills and a gristmill. Later, Joseph Clark built a sawmill and gristmill in the area known then as Milton Falls (today's Main Street area).

There were a number of areas that developed within the town of Milton. West Milton, Checkerberry, and Milton Boro all developed separately. The name Milton Falls was used for many years to designate the area near present-day Main Street and River Street (Route 7). After West Milton, Checkerberry became the site of development in Milton. The first town hall, or town house, was built here on land that was known as Checkerberry Green. Milton Boro developed an area for summer recreation. The first camp in Milton Boro was known as Camp Watson.

Throughout the years, Milton residents have served their country. In the War of 1812, fifty men from Milton fought, fourteen of whom are buried in Milton cemeteries. During the Civil War, over 200 men from Milton joined the Union army, including Dr. Lucious Dixon, a well-known

doctor, and Rev. J.H. Woodard, the chaplain of the 1st Vermont Cavalry. Of the town's Civil War veterans, 74 are buried in Milton.

From its earliest days, Milton has always supported at least one doctor in town. Among the earliest were Dr. Solomon Wyman, Drs. Jesse and Joseph Carpenter, and Dr. Avery Ainsworth. Later physicians included Dr. Franklin Hathaway, Dr. Benjamin Fairchild, Dr. Daniel Onion, Dr. Luman Holcombe, and Dr. Irving Coburn. Maurice Villemaire, who came to Milton in 1931, practiced medicine in town for 42 years.

Residents of Milton have faced their share of tragedies and challenges. An epidemic in 1813 caused the death of a number of residents. During 1816 (which became known as year with no summer), summer frosts were common, and snowstorms occurred. Crops were ruined, and there were shortages of food.

The first church in Milton was established on September 21, 1804. Rev. Lemuel Hayes and James Davis organized the church with 15 members. The first house of worship was constructed in 1806 or 1807. The Methodist church was organized early and had three houses of worship: one at Milton Boro, one at West Milton, and one at Milton Falls. The first Catholic Mass was held in the home of Etienne Perrault around 1844.

Between 1843 and 1845 or 1846, a weekly news sheet called the *Milton Herald* was published. The printing presses for the *Herald* were located in a building near the bridge across the Lamoille at Milton Falls. Later, in the 1800s, the *Milton Rays* appeared, published by F.S. Morgan. The *Milton Rays* later merged with another popular paper, the *Milton Times*, becoming the *Milton Rays-Times*.

Over the many years since the first settlers of European ancestry arrived, the people of Milton have worked to create a community. Often challenged by the harsh Vermont climate or disasters of water or fire, the people of Milton have persevered. I hope the images in this book give a sense of the community the people of Milton created. The people of Milton share a common past, and it is hoped that an appreciation of the past can help create a vision for the future.

One

MILTON FALLS

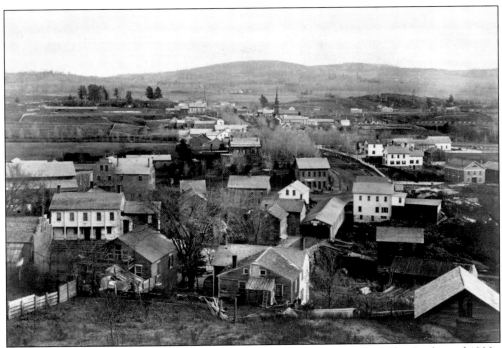

When Milton was chartered in the late 1700s, it contained over 60 square miles. By the mid-1800s, much commercial activity was centered in Milton Falls. This picture looks toward Main Street from west of the Lamoille River. The covered bridge was built in 1852. In the background, the spire of St. Ann's Church can be seen.

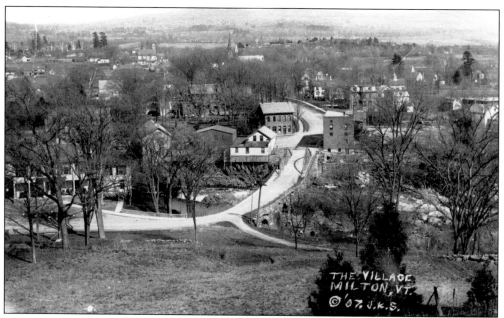

This picture, taken by Milton photographer J.K. Smith in 1907, looks east toward Main Street. The iron bridge (which had replaced the covered bridge in 1887) would later be destroyed in the flood of 1927. Main Street became the heart of Milton Village and was home to its doctors, lawyers, churches, and many merchants.

Pictured around 1900, this is the town square in Milton, near Main Street and River Street. Many of these buildings were destroyed in the flood of 1927. The businesses seen here are, from left to right, Hart's Cash Store, the wheelwright shop, Charles Ashley's carriage shop, and the gristmill.

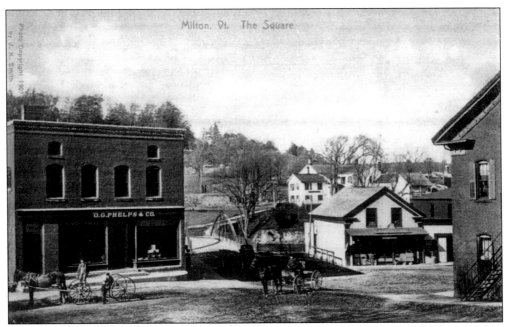

In this late-1800s view, the town square is located to the right. The O.G. Phelps store is on the left, and in the background is the bridge that was later destroyed in the flood of 1927.

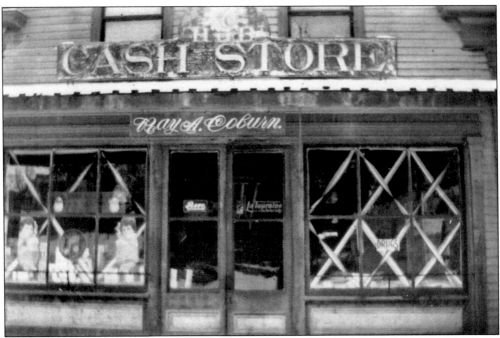

This photograph shows the Cash Store, operated by Ray Coburn. This wood-frame structure was located on the square in Milton Falls. The store was the equivalent of a general store, selling a wide variety of items. The building, like most of the structures on the square, was destroyed in the flood of 1927.

11

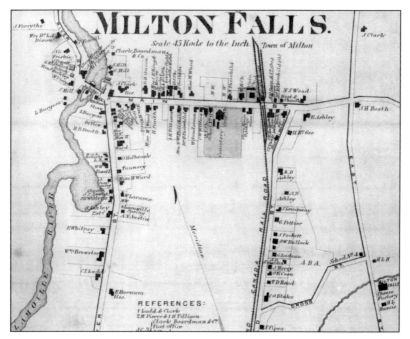

This 1869 map shows Main Street, Railroad Street, and River Street. The area was used for both residential and commercial purposes, and for over 200 years, Main Street was the heart of Milton Village. Near the bridge across the Lamoille River, a number of mills can be identified.

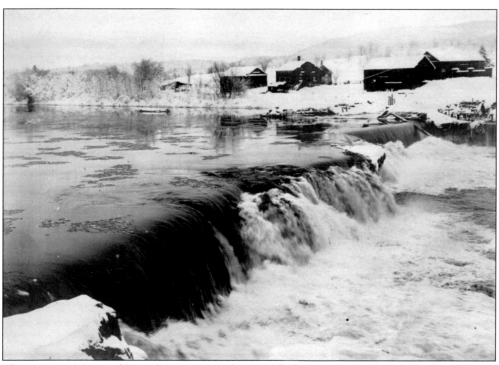

The area near Main and River Streets was made particularly attractive by the falls. In this eastward view across the river, the natural beauty of the falls is evident. For businessmen, however, they were most notable as a source of power for a number of mills, including a sawmill and a gristmill. Several buildings owned by Joseph Clark can be seen in this image.

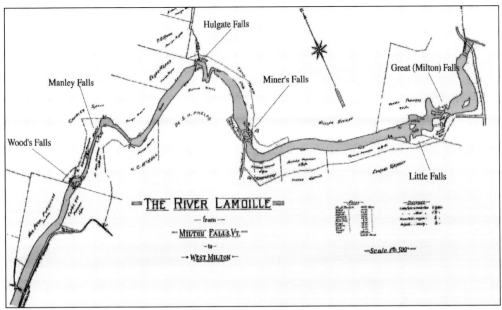

This map shows the various waterfalls on the Lamoille River as it winds its way through Milton. While the falls provided natural beauty, the reality is that rivers in Vermont often flooded. Dams may have removed some of the river's natural beauty, but they made it possible to harness the water flow for energy.

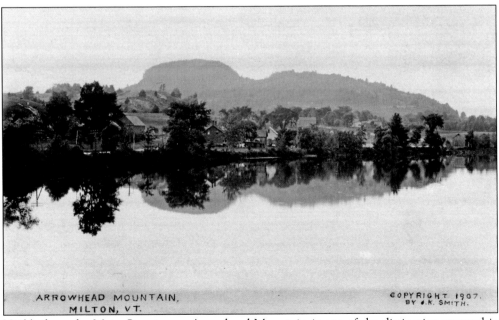

Visible from the Main Street area, Arrowhead Mountain is one of the distinctive geographic features of Milton. Although not one of Vermont's higher mountains in terms of elevation, its distinctive shape and interesting terrain attract hikers of all ages to its slopes.

This view is looking west down Main Street in the early 1900s. Noah Smith, one of Vermont's first lawyers, owned most of the land that would become Milton Village. In 1789, Elisha Ashley surveyed the first east-west road running through Milton Village, from the corner of East and Westford Roads to a stump on the bank of the Lamoille River. This road became Milton's Main Street.

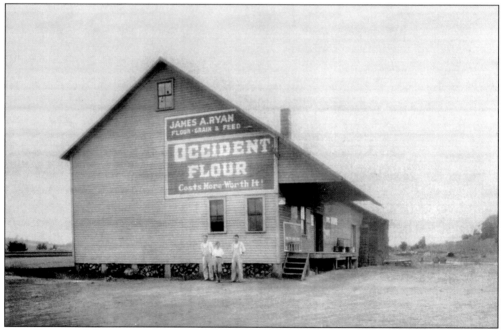

Main Street and the surrounding area became the commercial center of Milton. This is the J.A. Ryan Company Feed Store on upper Main Street. In the foreground, from left to right, are Clinton, James, and Paul Ryan. James A. and William P. Ryan purchased the store on June 3, 1913, from Heil McNeil, and the family operated it for many years. In the 1960s, it was the only feed store between Essex Junction and St. Albans. Today, it is the Oliver Seed store.

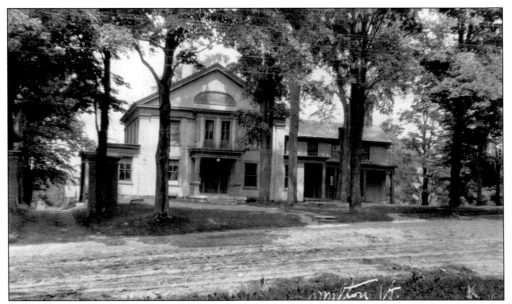

Main Street has a number of stately homes with a rich, varied architectural heritage. Perhaps none better captures the charm of Main Street than the home of Joseph Clark. Built in 1835, it would later serve as Milton's municipal building until 1994, when it returned to private ownership.

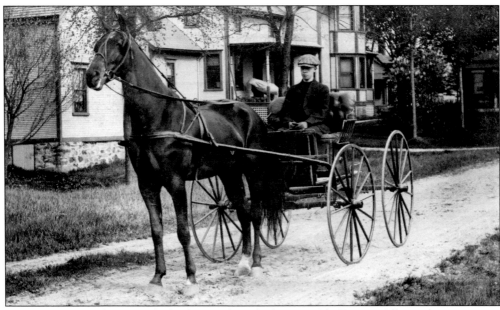

The Queen Anne home in the background was built in 1895 by Eugene Allen, a fine carpenter, for his wife, Adelaide. The house is on the corner of Main and Cherry (later School) Streets. In the foreground is Norman Skeels, the son of a local hotel proprietor.

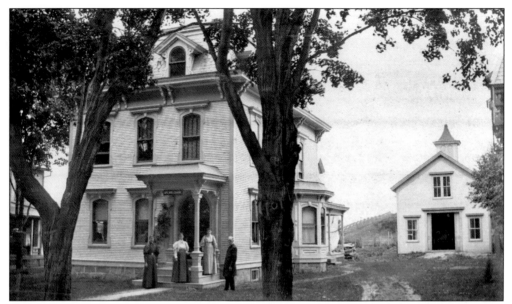

Charles Ashley built this Victorian home around 1880 on upper Main Street. During the late 1880s, the 18-room structure was the temporary home of Dr. Luman Holcombe, a well-known Milton doctor. The Phelps family owned the property from 1920 to 1946 and added double front porches that remain today.

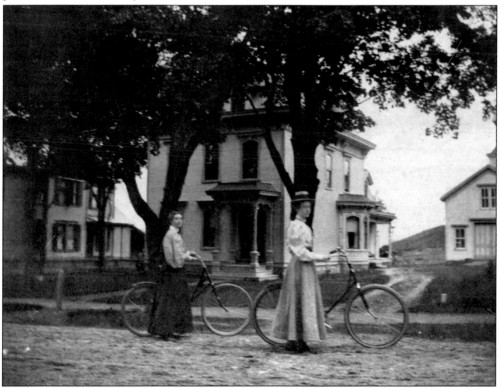

In this 1890s view of the home, Lillian (left) and Emma Pratt are pictured. The sisters were the daughters of Cassius Pratt, who owned a store on Main Street that burned in 1890.

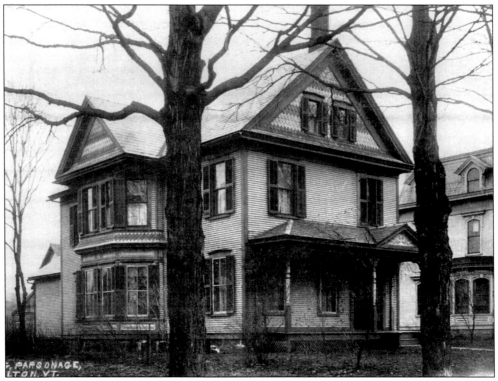

The Mears sisters moved this house to Main Street from the western part of Milton. In 1888, they willed their home to the Methodist church to be used as a parsonage. After the Methodist and Congregational churches decided to become federated in 1932, the house was sold. The wraparound porch was removed in the 1940s because of deterioration.

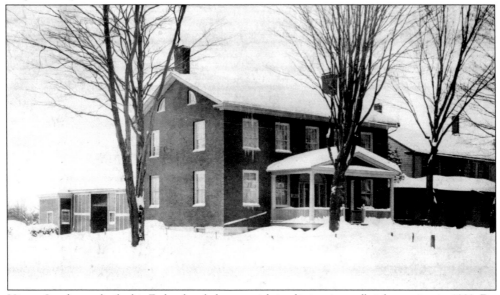

Hiram Sanderson built this Federal-style home, with its distinctive redbrick exterior, in 1929. Dr. Irving Coburn had his home and office there from 1907 to 1926. James Kennedy, a local merchant, owned the property until the 1950s, when it was purchased by Mary Skapski, a Milton teacher.

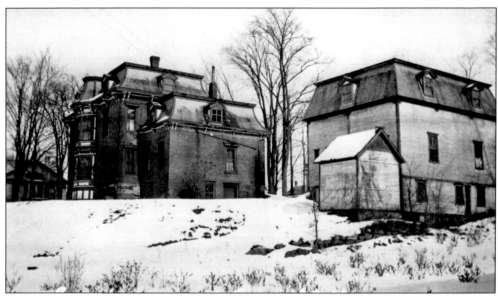

The Branch family built this attractive home near the bottom of Main Street on the site of the Boardman home after it was destroyed by fire. Perched high above River Street, it was not affected by the Flood of 1927. The home was used as a temporary schoolhouse in 1943 after the high school burned.

During the cold winter months, ice could be harvested from the Lamoille River, and there was an icehouse located behind the property of Joseph Clark on Main Street. Today, the public works department is located on Ice House Road, whose name commemorates what once stood at the site.

In 1913, Burr Martin opened a funeral home near the intersection of Main Street and East Road. He retired in 1941, after 27 years in the funeral business. Behind his house stood a small building that was used for services and storage. There were a number of farms nearby, and in the foreground of this photograph, Chester Ames is shown leading his steers.

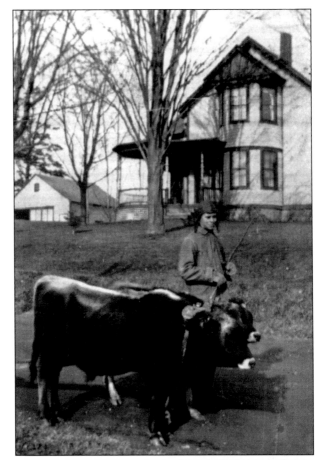

Prominent landowner Marion Ward owned this home (one of the first on Main Street) shortly after it was built in 1820. In the late 1800s, the structure was known as the Brown House. Over the years, the building was home to a number of prominent residents, including Dr. Wilton Covery, from 1948 to 1963.

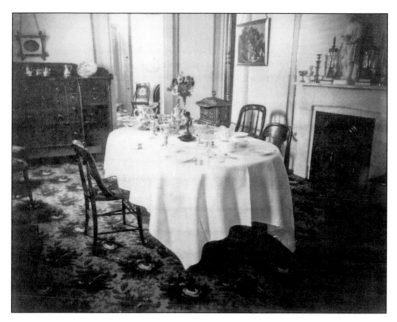

This picture of the dining room of the Marion Ward home captures the elegance of a Main Street residence. Although life could be difficult in northern Vermont during the 1800s and 1900s, many residents tried to create a comfortable existence. Ward shared her house with her cousin L.W. Landon and family.

This brick Greek Revival house was built in the 1830s. Through the mid-1800s, the Catholics of Milton were visited occasionally by priests of Burlington, and in 1844, the first Catholic Mass in Milton was held in this home. Dr. Corbin Sanderson owned the home from 1875 to 1905, and today it is operated as a bed-and-breakfast.

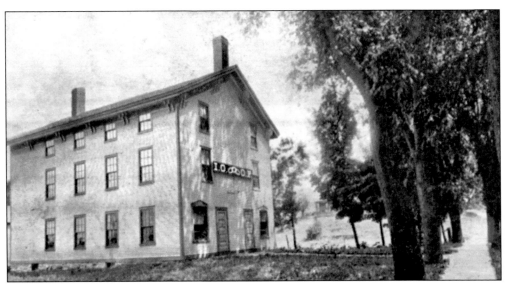

Built in 1865, the three-story Austin Hotel was one of the three hotels in the area then known as Milton Falls. It had a large meeting room as well as a recreation room, which hosted numerous events. It was known as the IOOF (Independent Order of Odd Fellows) Hall from 1905 to 1920, and in the mid-1900s, Earl and Bertha Bevins operated a movie theater on the first floor.

These two invitations are for events held at the Austin Hotel in late 1869 and early 1870. Milton had a lively social scene centered at a number of venues, including the Opera House on River Street and the hotel known as "the Rest" in Checkerberry.

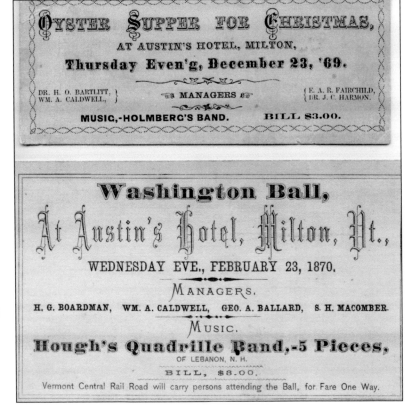

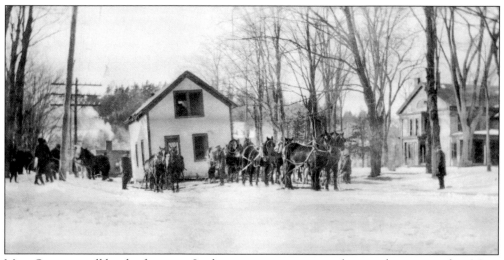

Main Street saw all kinds of activity. In this wintertime picture, a house is being moved up Main Street to a new location. At least 32 horses are involved in the enterprise. Apparently, though, it was easier to move a house then construct a new one.

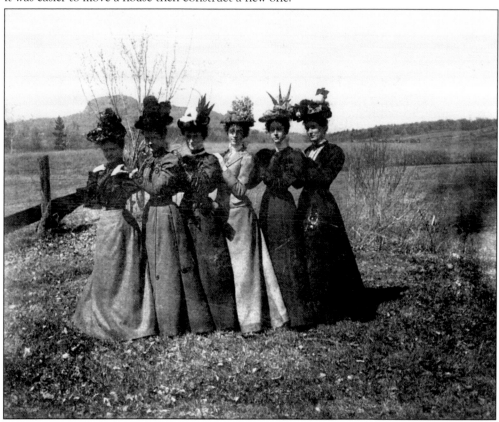

In the early 1900s, Milton had a thriving social scene. These six young ladies in their fashionable dresses and eye-catching hats are on the north side of Main Street, with Arrowhead Mountain in the background. Pictured are, from left to right, Ethel Benham Phelps, Agnes Quinn Laham, Jennie Rankin, Lillian Pratt Pierpont, Emma Pratt Drew, and Myrtie Rankin Robinson.

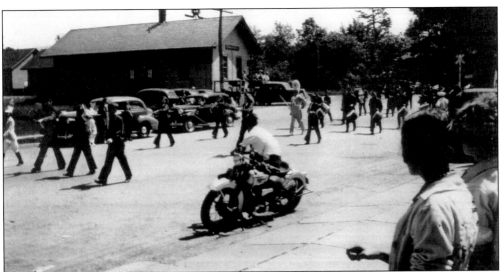

This picture from the 1940s shows a parade in progress near the railroad depot. As in many small towns, celebrations and commemorations were an important part of the community. No parade would be complete without a marching band, and this photograph included the drum major and supporting cast of band members.

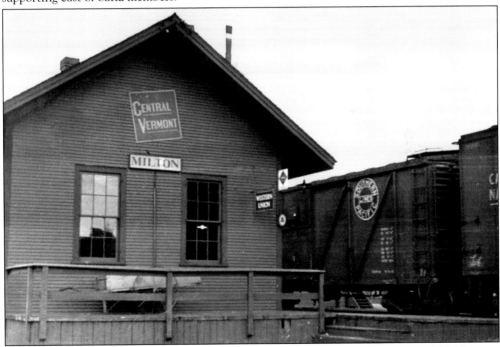

The Vermont & Canada Railroad was chartered in October 1845 as a continuation of the Vermont Central lines from Essex Junction to St. Albans, Swanton, and into Canada. In 1884, the Vermont & Canada was consolidated with the Vermont Central Railroad and began operating as the Central Vermont Railroad. In the 1800s, the future prosperity of a community often depended on its proximity to a rail line. Through the efforts of Joseph Clark and others, the railroad was brought through Milton, and by the early 1900s, the Milton station was busy with numerous trains each day. The station was closed in 1961 and torn down in 1971.

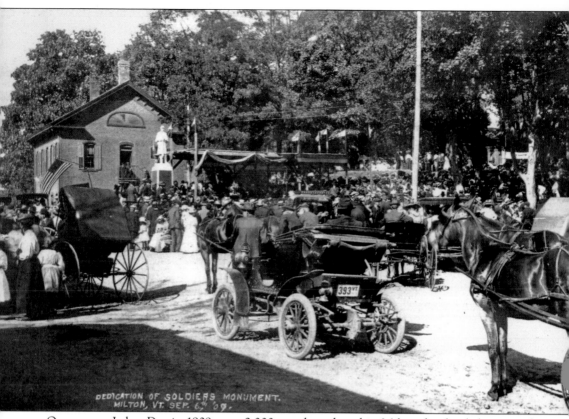

DEDICATION OF SOLDIERS MONUMENT.
MILTON, VT. SEP. 6.th 09.

On a sunny Labor Day in 1909, over 2,000 people gathered in Milton for the dedication of a monument to the local men who had gone to fight for the Union in the Civil War. The war had begun almost 50 years before, and its veterans and their supporters wanted to commemorate the sacrifice of the many young men who had left Milton to support the Union cause. In presenting the memorial, Col. H.O. Clark said, "It stands here complete today as we trust it will remain for thousands of years to teach the rising generations what their ancestors did in those arduous days of the Civil War." The statue is now known as the "Old Soldier." For many years, it stood at the intersection of Main and River (Route 7) Streets. It was later moved to the lawn in front of the former home of Joseph Clark on Main Street. It currently stands in front of the Milton Historical Museum on School Street.

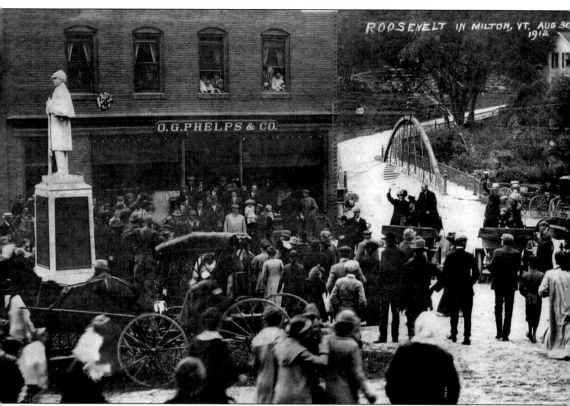

A few years after the dedication of the Civil War monument, Teddy Roosevelt came to Milton during his 1912 campaign for the presidency. Roosevelt had declined to run for reelection in 1908, and a philosophical difference between Roosevelt and his successor, William Howard Taft, split the Republican Party. When Roosevelt failed to secure the Republican nomination, his followers formed a new party with Roosevelt as the nominee. The group earned the name the Bull Moose Party. At the time, Vermont was seen as a very Republican state, and Roosevelt came in August 1912 seeking support for his candidacy. In addition to stopping at Milton, he also visited Burlington, Morrisville, and Barre. Despite Roosevelt's efforts, William Taft carried Vermont (one of only two states Taft won), and the split among Republicans allowed Woodrow Wilson to be elected president.

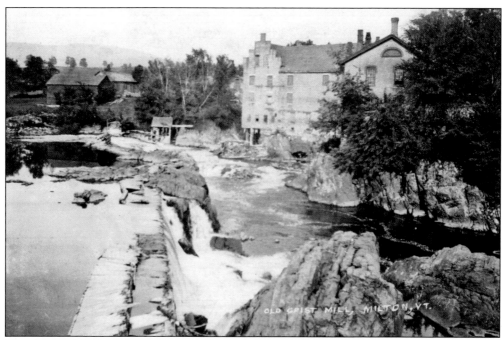

The charm of the varied architecture of Main Street and the surrounding area was supplemented by the commercial nature of many of the buildings. This photograph shows the river side of some of the buildings. This gristmill was located near the falls and the square in Milton; there were also other mills located along the river.

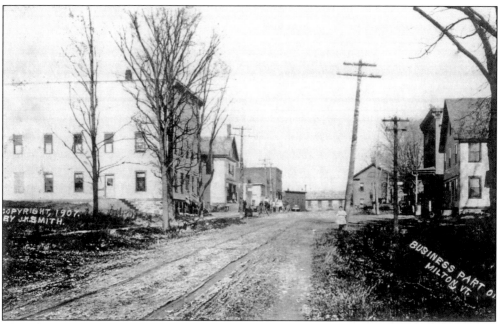

The other street that was central to Milton Falls was River Street, which intersected Main Street near the bridge over the Lamoille River. This picture is of River Street, looking north toward the square and Main Street. The Opera House is on the left.

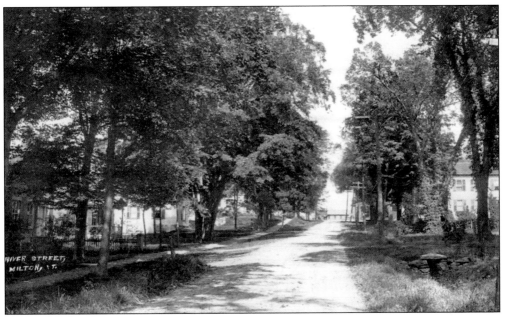

This is another view of River Street looking toward Main Street and the square. This section of River Street was more residential. Today, it would be near the intersection of Ritchie Avenue and Route 7, near the bottom of what was known as Gimlet Hill.

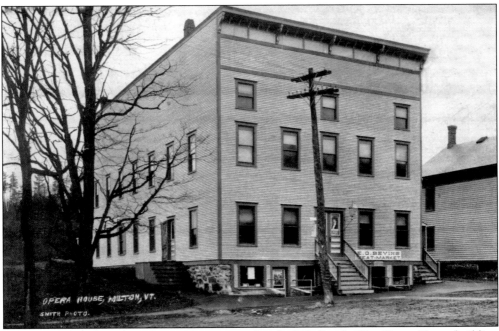

This picture of the Milton Opera House was taken by J.K. Smith. The Opera House building also housed the E. Bevins Meat Market on its lowest level. Performers, both local and from places like New York City and Boston, contributed to a lively social and entertainment scene during the late 1800s.

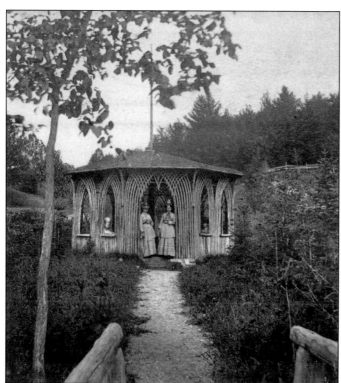

Not far from the Opera House on River Street was a spring and spa. In his recollection of Milton Falls in the 1870s and 1880s, P.C. Deming referred to the spa as a "rustic vine covered spring house." Known as Lamoille Mineral Spring, the waters were said to have restorative and curative powers.

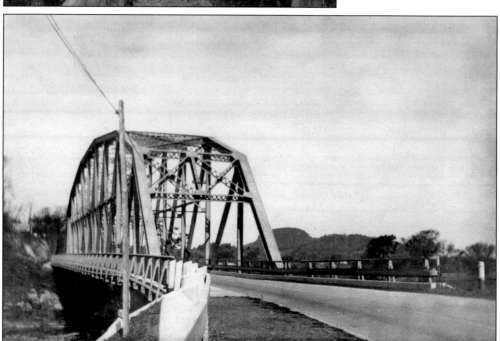

After the flood of 1927, this iron truss bridge was constructed over the Lamoille to replace the iron bridge that had been washed away, which itself had replaced the original covered bridge. Truss bridges were common from the late 1800s until the mid-1900s. In the mid-1990s, this bridge was replaced with a more modern structure.

Two

ALONG THE LAKE

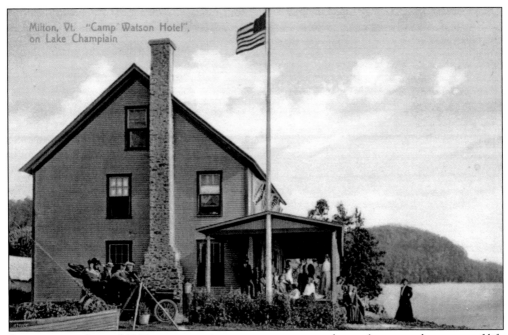

Beginning in the mid-1800s, camping in summer cottages and tents became a large part of life in Milton. In 1869, Camp Watson was established by Grace and Lucius Watson on a farm that had been in the Watson family for over 100 years. As with many camps, they first established a tenting area and boathouse. In 1879, Hiram Atkins of Montpelier, the editor of the *Times-Argus* newspaper, leased the land for a period of five years.

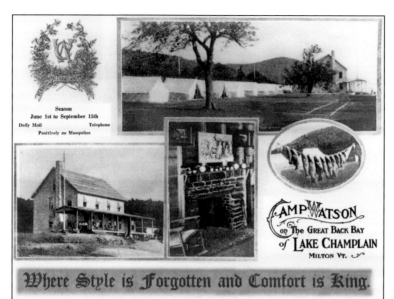

This brochure from Camp Watson appeals to people who want to get away from it all while maintaining contact via with mail and telephone services. It shows the tenting area as well as the main building. One wonders how the owners managed to keep mosquitoes away, as promised.

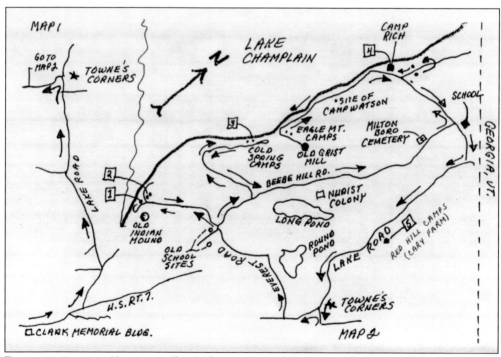

Encompassing over 60 square miles, Milton covers a large geographic area. The summer-camp area is removed from the village area. This map shows where many of the camps were located, as well as the possible routes for reaching them. Most could be reached by traveling Lake Road until reaching the shore of Lake Champlain.

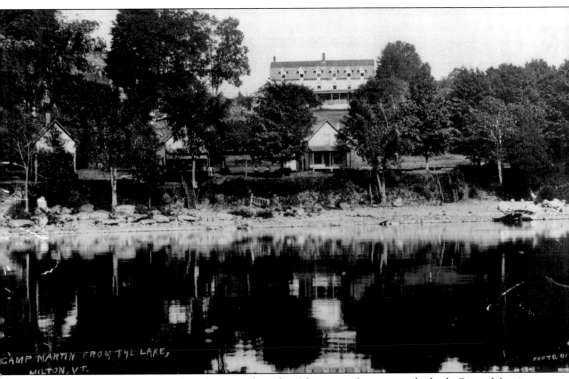

CAMP MARTIN FROM THE LAKE, MILTON, V.T.

This imposing structure in this photograph is the Algonquin Inn, around which Camp Martin was centered. The camp included the three-story inn, with its scenic views of Lake Champlain and the Adirondack Mountains to the west, as well as 16 cottages, a social hall, and a farm. For over 100 years, Camp Martin was operated by the Martin family (it would later be known as Camp Algonquin). Their advertisements promoted "a place of rest and comfort" for guests, with a healthy cuisine including "pure mountain spring water, cream, eggs, milk and vegetables from the Algonquin Inn Farm." Wilbert and Rita Patten owned the property from 1946 to 1979, during which time they converted the inn to a private home and removed the top story of the building. All of the camps offered a variety of recreational opportunities to their guests, including tennis, croquet, and quoits, a form of horseshoes.

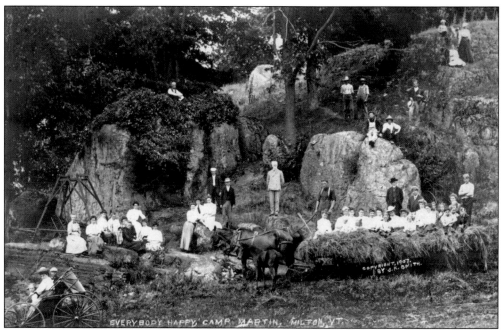

This group of Camp Martin visitors poses on rocks along Lake Champlain in this 1907 photograph. For visitors from places like New York and Boston, the shores of Lake Champlain provided relief from the summertime heat of urban areas.

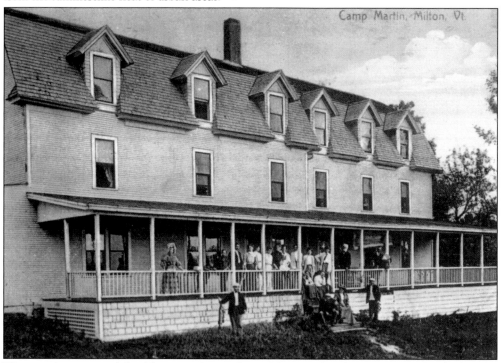

This is a closer view of the Algonquin Inn at Camp Martin. The elegant inn was finished in the early 1900s. It was named to honor the Algonquin Nation, whose members had camped for many years on these shores on their annual migration from winter to summer lodges.

In 1878, Zebediah Everest and A.W. Austin opened the original Camp Everest. This picture of a section of the camp shows the geographical feature known as the "Indian Mound." The camp included a camp house, bowling alley, and eight cottages. Many descendants of Zebediah have operated the camps, including Ira and Ethel Everest from 1919 until 1960.

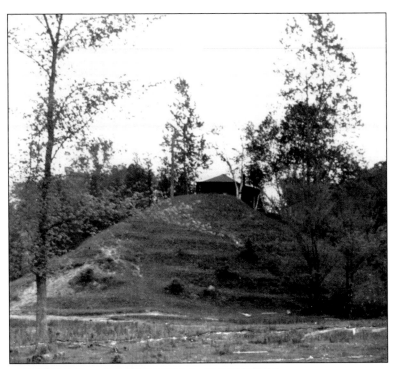

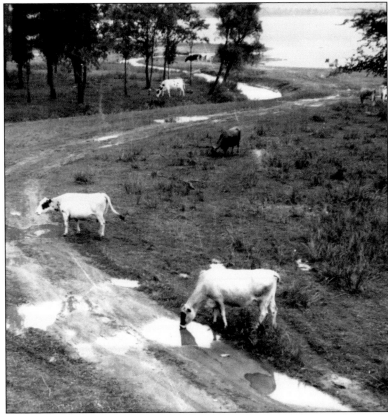

This picture shows farm animals roaming freely along the road to Camp Everest. Milton Boro, where the camps were located, boasted a number of farms to keep the camps supplied with fresh food. In 1960, Herb and Phyllis Everest bought the old farm on the Camp Everest property.

As pictured here, visitors arriving in Milton via the Central Vermont Railroad were met by a carriage. As many as eight trains would stop at Milton each day to deposit guests. The carriage transported the visitors approximately six miles to the shore of Lake Champlain, where guests had the options of camping in tents or staying in more comfortable inns. Some visitors arrived by boat from the docks at Burlington or St. Albans. The average price per week to stay at a camp was between $8 and $10. Some camp owners leased lots to guests who returned every year, allowing these annual visitors to construct their own cottages. Many residents found seasonal employment at the camps as waitresses, cooks, and handymen. Moss Hart, of musical comedy fame, was one of the many guests from around the country who came to the shores of Lake Champlain in Milton; he directed a dramatic workshop in the area one summer.

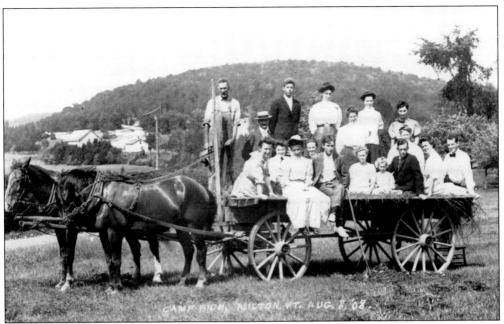

This group of visitors to Camp Rich enjoys a hayride along Lake Champlain. The camps offered varied recreation, and Camp Rich, located on a bay, was known for its fishing. Charles Rich, the original owner, took fishermen from nearby towns to catch bass, and these day trips led to overnight stays. Duck and grouse hunting occurred in season.

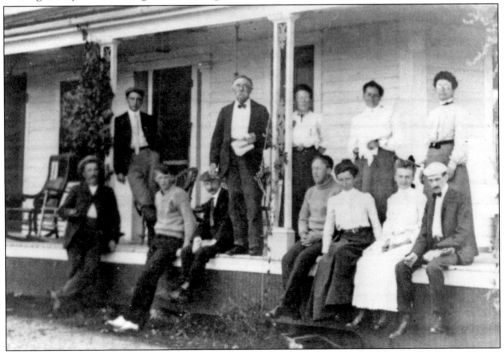

Another group of campers is enjoying some leisure time on the porch of Camp Rich. Brochures for the camp advertised accommodations for over 100 guests, including dry tents with double covers for those who desired a real camping experience.

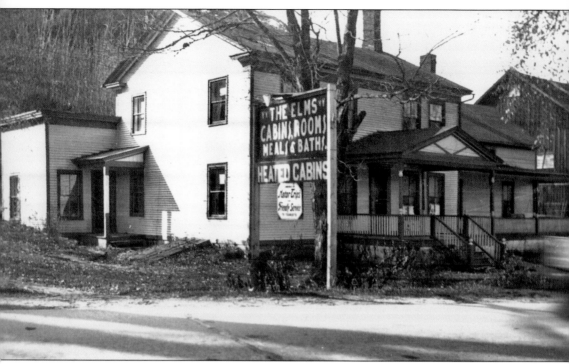

In the early 1930s, the Elms, operated by Alex and Laura Paquette, opened just north of the bridge on Route 7. The business included a restaurant; riding stable; and at least 13 cabins, some of which were named after the dwarfs in Disney's *Snow White and the Seven Dwarfs*. When the dam was built in 1937, the main house and some other buildings were moved to higher ground. In 1957, Thomas and Mary Curran acquired the business. The restaurant was closed in 1965, and the tourist business declined, finally ending in 1981.

In 1922, John and Pearl Hoyt purchased 100 acres on the shore of Lake Champlain. They began to construct housekeeping cottages as well as their personal residence on the property. The camp, known as Cold Spring Camp, got its name from the cold-water spring on the beach. In the 1990s, the camps were sold to individual families, and the Hoyt family donated a large part of the property on scenic Eagle Mountain to the Lake Champlain Land Trust.

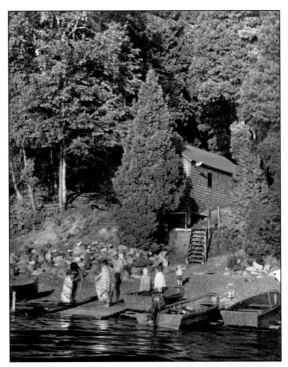

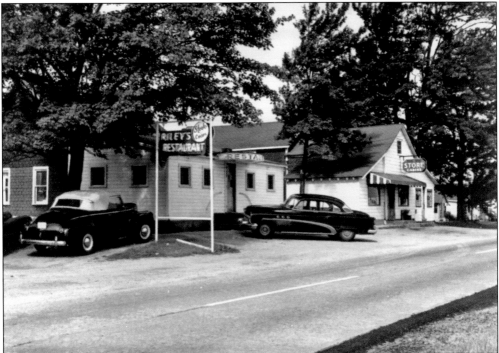

Other vacation lodging was spread throughout Milton. Fred and Florence Riley purchased West View Cabins in the mid-1940s, on the location of the current Sarah Marie Apartments on Route 7, near its intersection with West Milton Road. The Rileys opened a restaurant in 1951 and sold the property in 1963.

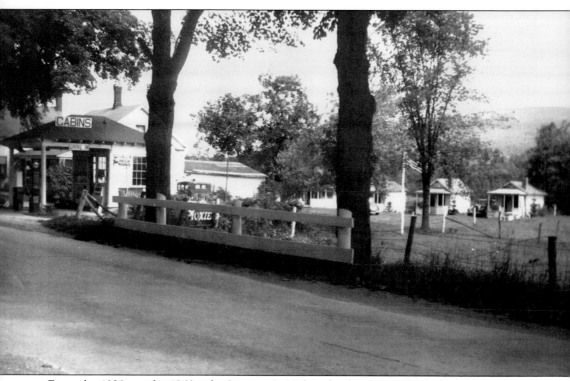

From the 1930s to the 1960s, the Luman C. Holcombe family operated The Maples Tourists Camps one half mile north of the bridge on Route 7. The Holcombe family purchased the property (originally a 59-acre farm) in 1927 and soon after constructed cozy, electric-lighted cabins with running water.

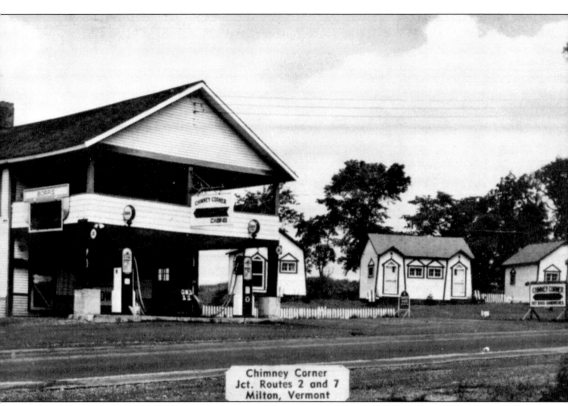

Chimney Corner
Jct. Routes 2 and 7
Milton, Vermont

The Chimney Corner Cabins were located at the intersection of Routes 2 and 7 and near the intersection of Route 2 and Interstate 89. In the 1950s, as Americans took to the highways, the cabins provided inexpensive lodging to tourists who wanted to explore the area. The area is still known by local residents as Chimney Corners.

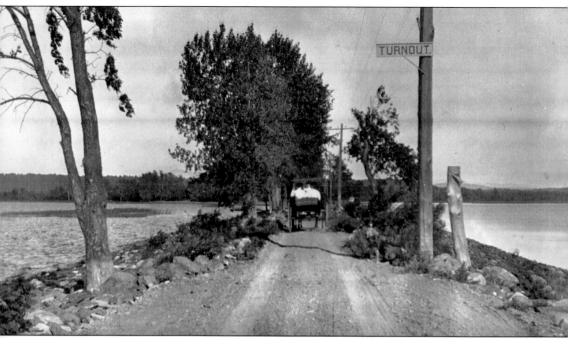

Before a causeway was ever built connecting Milton to the Lake Champlain Islands, a sandbar allowed people to cross the lake in summer and fall. In the 1840s, a group of investors created a more permanent crossing with rocks and gravel. A.G. Whittemore, a prominent Milton lawyer, was responsible for constructing the road through the swamp leading to the sandbar bridge. Tolls were collected on the South Hero side. Ice and water caused yearly damage necessitating constant repairs, and investors never saw a return on their investment because of the need for these repairs. The Vermont Department of Highways took over maintenance of Sand Bar in 1907, and tolls were no longer collected. After World War I, as automobiles became more popular, the road across Sand Bar was improved by raising and widening the road and creating regular turnouts so vehicles could pass each other.

Three

ON THE FARM

Farming has always had a prominent role in Milton. For settlers looking for a plot of land to start a self-sufficient farm, the area around Milton was full of promise. Corn (which could be taken to the gristmills along the river), oats, wheat, rye, and potatoes were some of the first crops raised. In the 1840 Census, Milton is recorded as having 2,863 cattle and 16,000 sheep and producing 49,971 bushels of potatoes and 31,686 pounds of wool. This picture shows the Everest Farm on Beebe Hill Road. When farms were first developed, the land was cleared of trees and brush. Tree stumps were made into fences, and trees were burnt, with the ashes processed into potash.

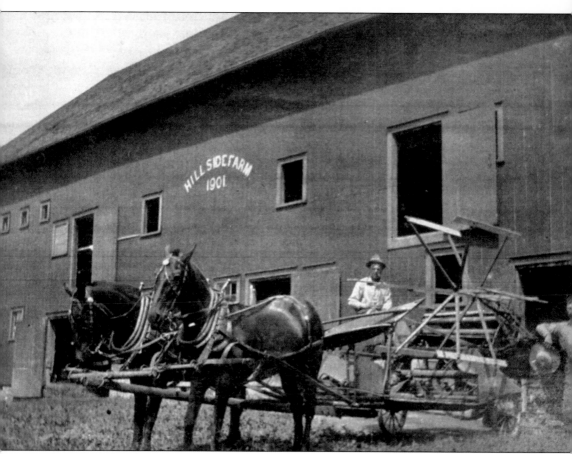

Farms are often handed down from generation to generation. In this picture from the Hillside farm, Frank Cary is on the left and his son Howard Cary is on the right. Frank purchased the farm from Samuel Howard in 1892. It had been in the Howard family over 100 years. Frank's son Howard operated the farm for many years, and it was sold to Howard's son Franklin and his wife, Odessa, in 1947; they operated the farm for many years. The barn pictured here burned in 1926 and was replaced by the present barn. The farm has been in the Howard/Cary family for over 200 years.

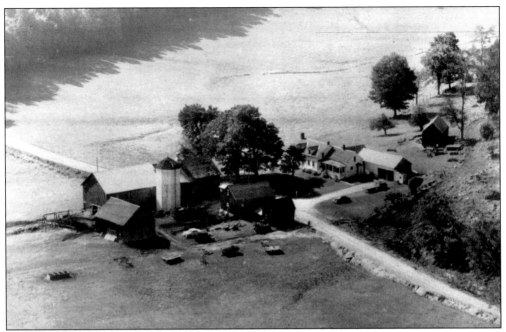

This large farm, located on Cadreact Road, was owned by S.W. Flinn in the mid-to-late 1800s and was one of two farms purchased by John and Matilda Cadreact in the early 1900s. It was operated by their son Harold and his wife, Rosanna, from 1921 to 1980.

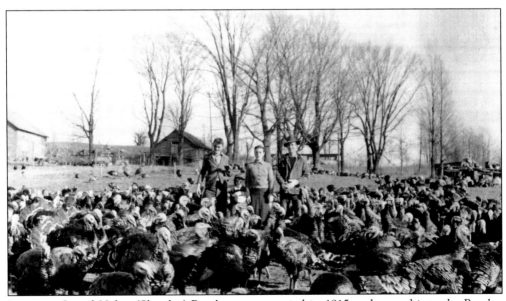

Lawrence J. and Helen (Shanley) Rowley were married in 1915 and moved into the Rowley homestead on Lake Road. Their family of 10 children helped care for 75 head of cattle and the thousands of turkeys that Helen successfully bred. The Rowley family is still active in farming.

Lucius Learnard established the Learnard-Manley homestead around 1850. It was located north of the village of Milton to the east of Arrowhead Mountain, overlooking Arrowhead Mountain Lake. In the late 1800s, James Manley and his wife, Marietta (Learnard), owned the property. The barn in the picture was destroyed by fire in October 1944. The property remained in the Manley family until it was sold to the Husky Injection Molding Company in 1997.

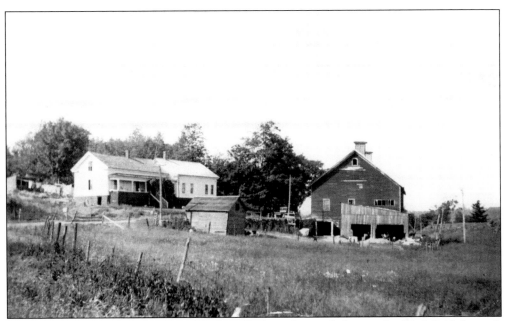

One of Milton's first settlers was Absalom Taylor, who settled near the Littlefield farm. A Revolutionary War soldier, Taylor was buried in the West Milton Cemetery. In the 1930s, Harold and Cora Littlefield acquired the property. This picture was taken about 1937.

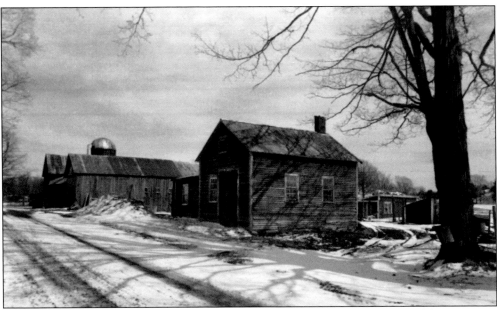

One of the first settlers to establish a farm was John Sanderson. He was a veteran of the American Revolution and came to Milton with his wife and four sons in 1804 from Massachusetts. The Sanderson farm is pictured here. Their original plank house was destroyed by fire in 1831. On the right in the picture is the blacksmith shop, built before the Civil War. On the left is the large cow barn. Most farms had a few barns to house horses, cows, and other animals.

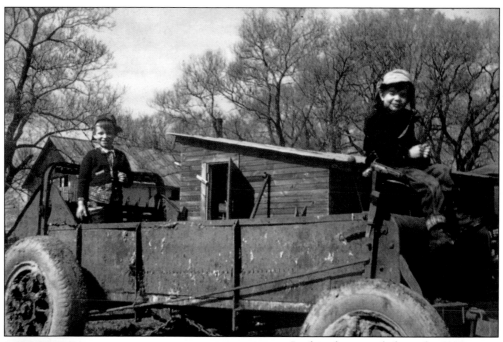

In this photograph from the 1930s, two Mayville children sit atop a farm wagon. Farming often became a multigenerational family tradition, and the Mayvilles operated their farm from 1919 until 1985.

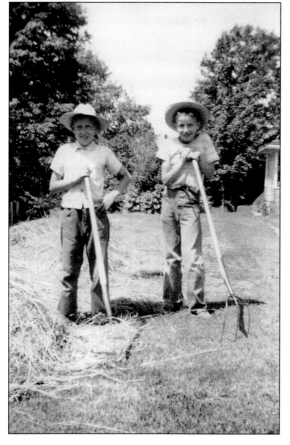

Children who grow up on a farm are expected to pitch in with various chores. Here, Roger Myott and Jack Campbell help on the Glazier Farm on East Road in the 1940s. Work on a farm never stopped, and there were many ways children could contribute.

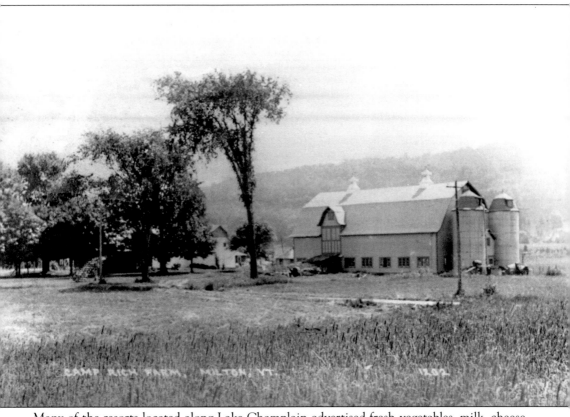

Many of the resorts located along Lake Champlain advertised fresh vegetables, milk, cheese, cream, and eggs. Pictured above is the dairy farm at Camp Rich, established by Charles Rich and carried on by his descendants David Bean, George and Harold Taylor, and their families.

Haying, an annual task for dairy farmers, takes many days. Pictured above in the early 1900s are members of the Sanderson family collecting hay. A farmer needed to be a jack-of-all-trades who could learn a variety of tasks on the job.

Sugar-making has been a tradition for many farmers. The season starts in early March and with cooperating weather can extend until early April. This sugarhouse was located on the Mayville Farm on North Road. Cortice and Venice Mayville operated the farm from 1919 until 1945, when their son Edward and his wife, Elaine, took over. They carried on the family farming tradition until 1985.

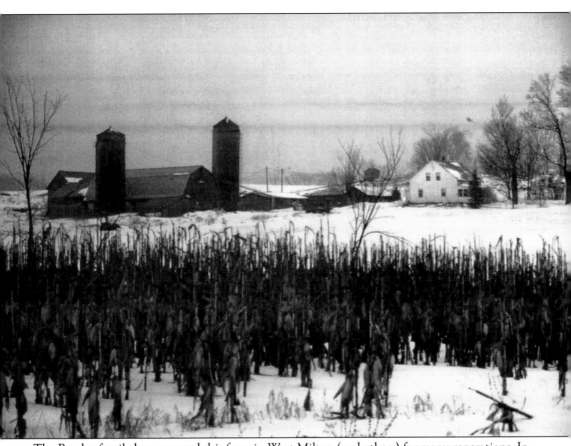

The Rowley family has operated this farm in West Milton (and others) for many generations. In 1953, Milton had 90 active dairy farms. By 1965, the number had dropped to 55.

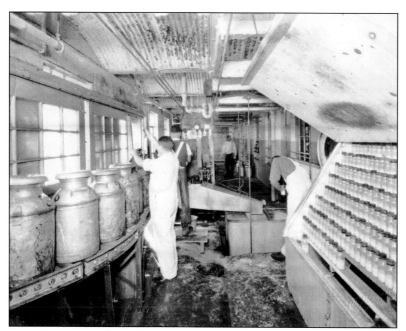

This picture from inside the creamery shows the receiving room, where milk would begin to be processed after delivery. At its peak, the Milton Co-Op was one of the largest in New England, doing more than $5 million worth of business in a year and employing around 40 to 50 people.

These creamery employees, pictured around 1920, are, from left to right, George Boclair, Roy Morgan, Charles Lovely, Milton Roberts, Cory Osgood (in back), Bob Smith, and Ralph Ryan. The creamery employed over 50 people at its peak.

MILTON CO-OPERATIVE DAIRY CORPORATION, MILTON, VT.				*Milton* PLANT	**H 38437**

PRODUCER *Geo. Lapow* NO. *1* ZONE *25*

PERIOD *12-31* 19*51*	ANNOUNCED 3.7 PRICE	*5495*		CHARGES	
	LESS	*03*	BUTTER	$ *8.10*	
B. F. DIFFERENTIAL $ *.10*	B. F. COUN. DUES	*005*	HAULING		
			HAULING TAX		
CREDITS			KEROSENE		
	NET 3.7 PRICE PER CWT.	*546*	GASOLINE		

	POUNDS CREAM OR MILK	TEST	PRICE PER CWT	VALUE	OIL	
MONTHLY SETTLEMENT 1-15	*3466*	*3.5* @*5.26*	*182.31*	STRAINER PADS	*1.50*	
16-31	*3291*	*3.4* @*5.16*	*169.82*	STOCK SER *prestone*	*7.30*	
				bank	*6.67*	
ADVANCE PAYMENT 1-15		@		*prod. Cr.*	*42.00*	
				ADVANCE PAYT.	*182.31*	
				TOTAL $	*247.88*	
				CHECK TO BALANCE $	*104.25*	

DO46 TOTAL *352.13*

This ticket was issued to a farmer by the Co-Op to settle payments and expenses. Expenses seem high relative to the final check written to the farmer. The price of milk could fluctuate quickly, and farmers could be charged for a variety of expenses.

John McGrath was one of the original founders of the Milton Co-Op and later served as president of the corporation. He resigned in 1953 as the Co-Op began to face financial challenges, and Ray Rowley became president. The creamery was closed in 1974.

The Milton Co-Op was not the only creamery in Milton. Earl Costello (left) and Clark Mitchell, employees of the West Milton Creamery, are pictured here. West Milton had a number of large farms, and the West Milton Creamery provided easy access for the farmers' product.

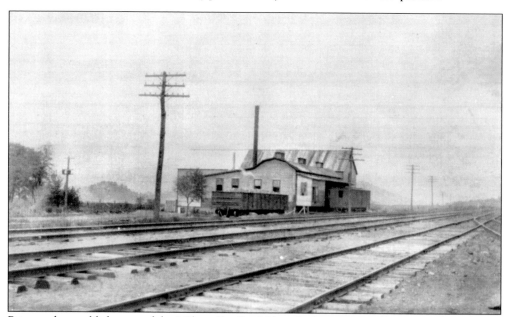

Prior to the establishment of the Milton Co-Op, Milton had a creamery (known as the Whiting Creamery) located north of the train station. The decision by Joseph Clark and others to pursue the railroad proved beneficial to farmers, as the Whiting Creamery could ship dairy products from Milton to remote locations.

Four

SCHOOLS

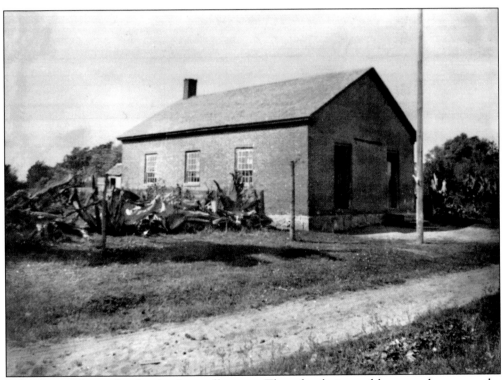

Schools are often a focal point in small towns. The school pictured here was known as the Checkerberry School. The Checkerberry area of Milton was named for the wintergreen plant that grew abundantly in the region. In the early 1800s, it was one of Milton's busiest areas. This school was built along the stage road, and records show a dramatic increase in students, from 33 to 64, between 1802 and 1805. In 1912, the brick school was replaced with a wooden structure, which was used until schools were consolidated. American Legion Post 67 purchased the property, and although a fire damaged the structure in the early 1970s, the building was renovated and is still owned and operated by the American Legion.

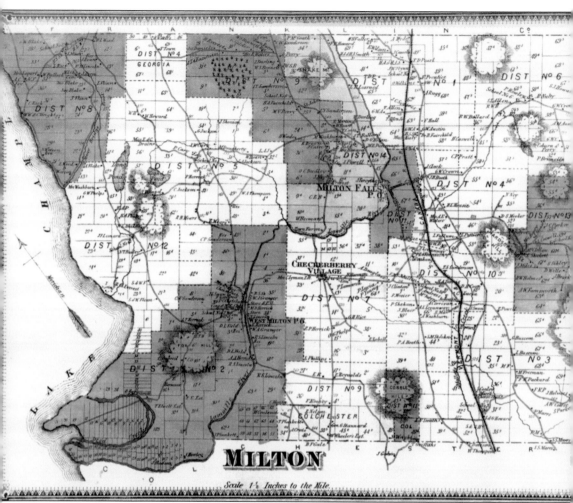

Without modern transportation, early Milton settlers had to establish schools close to where people lived. This map shows the 14 school districts of Milton that existed in 1869. People living in the various sections of town took it upon themselves to start schools for their children. The first was built in 1806 on what is now Main Street. It was a one-story brick structure near the current site of St. Ann's Church. This school burned and was replaced by a two-story school. On River Street was a "Young Ladies Select School," offering courses such as Latin and Greek to young women who wanted to further their educations. As people settled in the various parts of Milton, one-room schoolhouses were built. The need for 14 schools dissolved as transportation became easier.

The Snake Hill School, pictured here, was located near the current Lake Road and Manley Road. Snake Hill was the early name for Arrowhead Mountain. A school newspaper published in 1894 documents students learning about useful tools, a pet squirrel, and frogs.

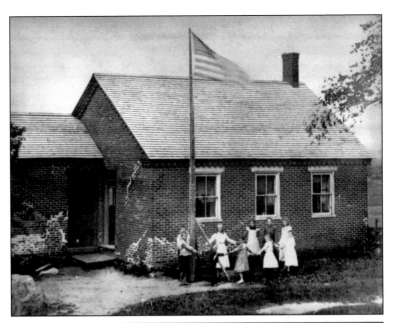

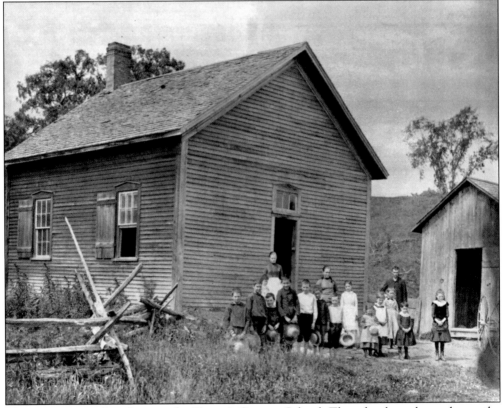

This is a picture of students at the Towne's Corners School. The school was located near the intersection of Lake and Hibbard Roads. Establishing schools is one challenge, but obtaining funding for them is another. On June 5, 1807, the voters of Milton agreed to support a school the following year.

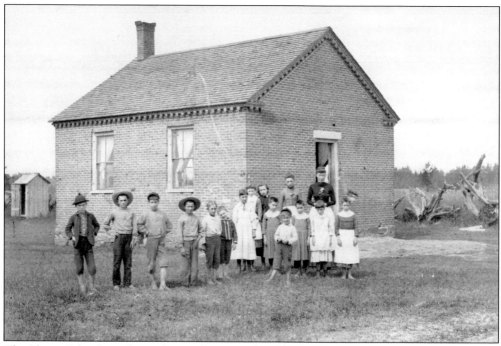

The Plains School was located near the area of Hobbs Road and Middle Road. In an annual report from a town meeting 1819, four of seven items to be voted on are school matters. In 1862, the town voted a property tax of 10¢ on the dollar to pay school expenses.

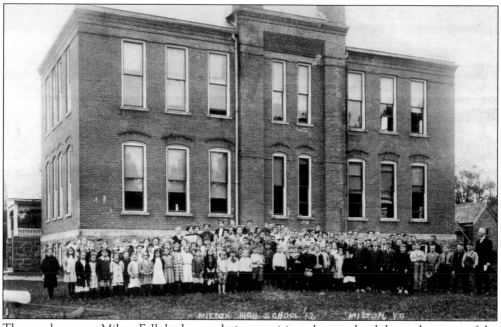

The area known as Milton Falls had a population requiring a larger school than other areas of the town. In this picture from 1913, students are standing in front of the school, which was located at the corner of Cherry and School Streets.

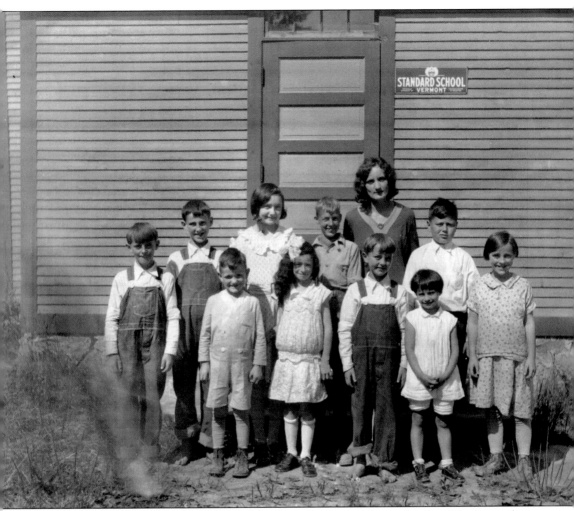

The Towne's Corners School was named for the early Eugene Towne family. This picture from 1930 includes many longtime Milton residents. With teacher Janice (Mears) Larrow are, from left to right, (first row) Aloysius George Rowley, Eugene Towne, Elinor Rogeine Lovely, Patrick John Thomas Rowley, Villa May Lovely, and Frederica Jane Rowley; (second row) Lawrence James Rowley, Helen Phyllis Towne, Herman Pierce Corliss, and Frederick George Lemnah. The sign on the wall identifies this as a standard school, meaning that the institution could provide adequate supplies, had proper heating and ventilation, and was correctly lighted. Bathrooms also had to be sanitary and in good working order. The standardization movement also required a teacher to have 24 weeks of prior teaching experience before her school could be rated "superior."

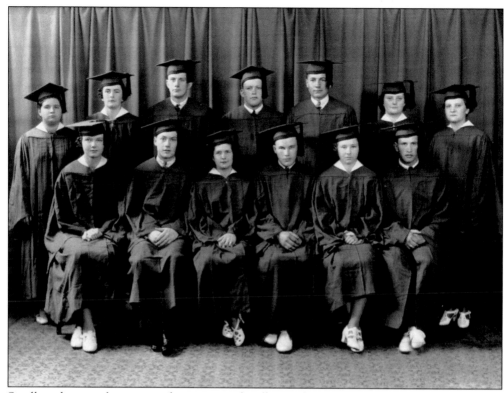

Small graduating classes were the norm until well into the 20th century. This class from 1937 has but 13 members and has the distinction of being the first class to have its commencement in the new high school auditorium. Pictured are, from left to right, (first row) Edithe Berry, Hiram Bevins, Grace Thompson, Milford Bushey, Alice Trayah, and Clifford Turner; (second row) Dorothy Guerin, Martha Baker, Samuel Baron, Max Garrand, Clinton Baxter, Helen Browe, and Norma Hayden.

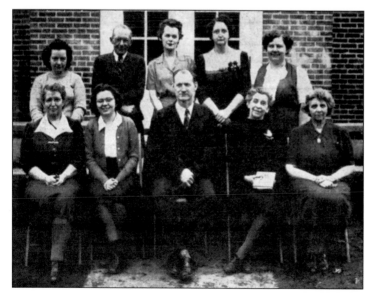

Pictured here is the faculty of the Milton Graded School in 1945. They are, from left to right, (first row) Clara Gardner, Louise Comings, Ernest Codding, Mary Kennedy, and Grace McDonald; (second row) Gladys Watson, Julius Bluto, Marjorie Powell, Edith Holden, and Lois Hobbs. McDonald, Holden, and Kennedy all taught for more than 40 years in the Milton school system.

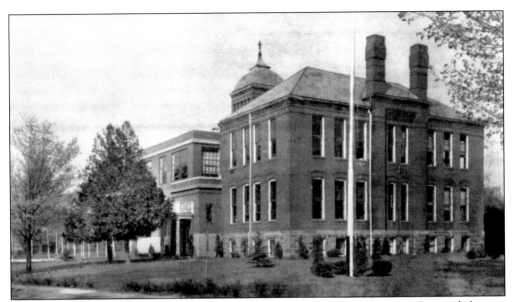

As the population of school-age children grew, so did the need for more space. Pictured above is a new addition to the high school. The new six-room wing was added in 1936. The high school was one of the few schools in the area with a gymnasium and auditorium.

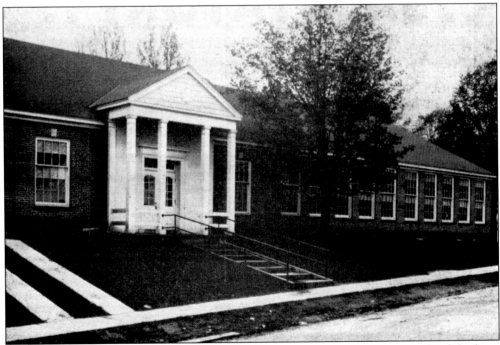

A fire destroyed the high school in February 1943. Pictured above is the new school, built on the same site at the corner of School and Cherry Streets. The new building was constructed in a little more than a year, which was particularly remarkable since supplies and labor were scarce due to World War II.

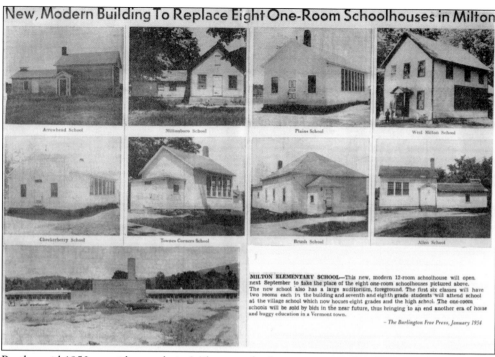

New, Modern Building To Replace Eight One-Room Schoolhouses in Milton

Arrowhead School

Miltonboro School

Plains School

West Milton School

Checkerberry School

Townes Corners School

Brush School

Allen School

MILTON ELEMENTARY SCHOOL—This new, modern 12-room schoolhouse will open next September to take the place of the eight one-room schoolhouses pictured above. The new school also has a large auditorium, foreground. The first six classes will have two rooms each in the building and seventh and eighth grade students will attend school at the village school which now houses eight grades and the high school. The one-room schools will be sold by bids in the near future, thus bringing to an end another era of horse and buggy education in a Vermont town.

– The Burlington Free Press, January 1954

By the mid-1950s, rapid growth in Milton made the one-room schoolhouses obsolete. This story from the *Burlington Free Press* announces that the local schools will be consolidated in a new elementary school. While some might mourn the loss of one-room schools in the 1950s, consolidation was seen to have many benefits.

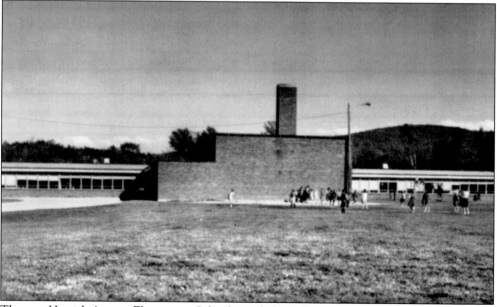

The new Herrick Avenue Elementary School was dedicated on November 7, 1954. From 1945 to 1950, enrollment in Milton schools had doubled from 95 students to 197. As the town continued to grow, two additions of six rooms each were added between 1965 and 1968. The school also expanded in the late 1970s, and again in 1998, when a two-story addition was built.

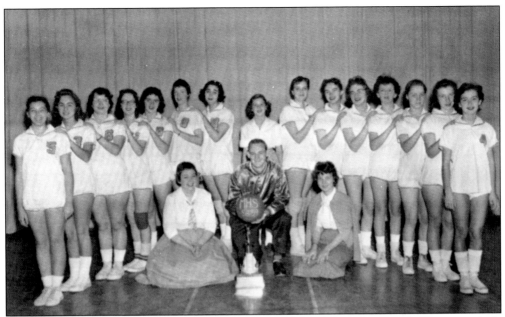

High school sports are an important part of many students' experience. Basketball is particularly popular, and this 1959 photograph shows the Milton High School (MHS) girls' basketball team. Pictured are, from left to right, (first row) Frances Houghaboon, Stan Folsom (coach), and Maureen Morris; (second row) Ilene Trayah, Regina Sweeney, Linda Smith, Pamela Norton, Mary Duffy, Barbara Norman, Janet Desranleau, Leta Pidgeon, Sandra Johnson, Ellen Duffy, Theresa Duffy, Elizabeth Marcoux, Sandra LaCross, Sheryle Sheltra, and Sandra Root.

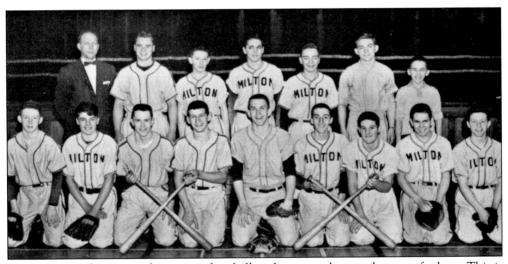

When the weather warmed in spring, baseball took over as the popular sport for boys. This is the MHS team from 1956. Pictured are, from left to right, (first row) Ronnie Wagner, Leon Blow, Alton Lombard, Giles Jackson, George Gover, Ebbie Johnson, James Manley, Tommy Parizo, and Randall Cary; (second row) Raphael Morris (coach), Armand Turner, Carl Duffy, Billy Mills, Eddie Ratte, John Roy, and Larry Duffy.

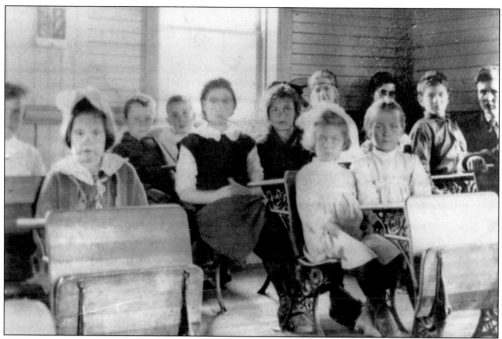

These students are attending the Milton Boro School on Beebe Hill Road in the early 1900s. The Milton Boro area hosted summer guests at the camps along Lake Champlain and also served a permanent population that built a church in addition to the Milton Boro School.

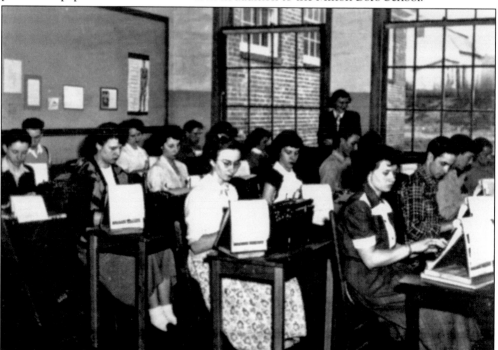

This high school typing class in the late 1950s was typical of schools at the time. The picture also shows that the population of school-age children was growing. It would not be long before a new high school would have to be built.

This is an early, rather fierce depiction of the Yellow Jacket, the longtime mascot of Milton High School. Although the depiction has changed over the years, the Yellow Jacket remains the mascot of Milton's sports teams, and the school colors are royal blue and gold.

A growing population also meant the need for more space for high school students. Seen here is the newspaper account of the ground-breaking ceremony for the new facility.

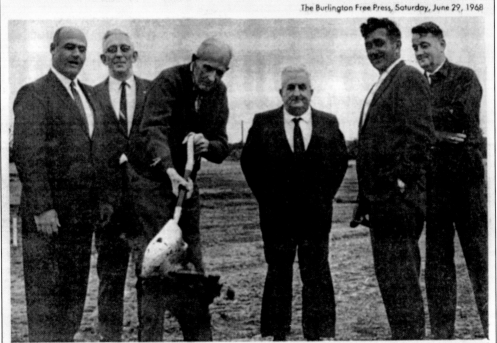

The Burlington Free Press, Saturday, June 29, 1968

MILTON HIGH SCHOOL GROUNDBREAKING took place Friday morning with one of the town's outstanding senior citizens, Mark W. Melaven, 88, tossing the traditional first shovelfull of dirt. Also participating, left to right, School Board Chairman Thomas Curran, Board member Leonard Branch, Selectman George Thompson, and School Board members Keith Lombard and Duane Ryan. The existing high school will be used to accommodate an overflow of elementary school pupils when the new building is completed.

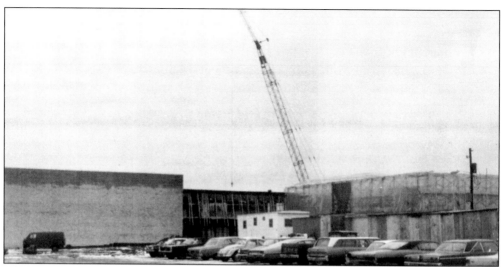

This 1968 picture shows construction in full swing. The new high school opened in 1969 to meet the needs of a growing community. During the 1960s, local employers like IBM expanded, bringing more people to the area. By the standards of the time, the new school was quite modern, with science labs, gymnasium, auditorium, and cafeteria.

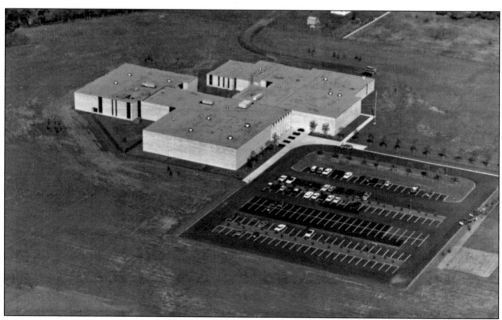

This aerial view of the new high school shows the building and surrounding athletic fields. Enrollment continued to grow from the late 1960s until today, with graduating classes numbering well over 100 students throughout the last 10 years. On any fall or spring afternoon, the athletic fields around the school are filled with many student athletes.

Five

BUSINESSES, CHURCHES, AND ORGANIZATIONS

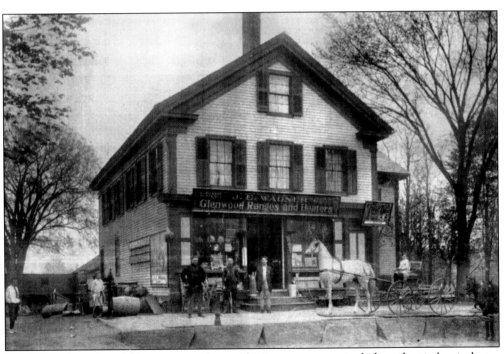

From its earliest days, Milton attracted many business ventures, including the timber industry and a variety of mills, and the area around Main and River Streets was particularly busy. This two-and-a-half-story building was constructed by George Ashley in 1850 and was acquired by the Zebbie Wagner family in the late 1800s. During the early 1900s, Zebbie's son Joseph Wagner purchased the store. Later known as the E.W. Miller store, it was one of the largest hardware stores in the area, selling stoves, farming implements, carriages, sleighs, and automobiles.

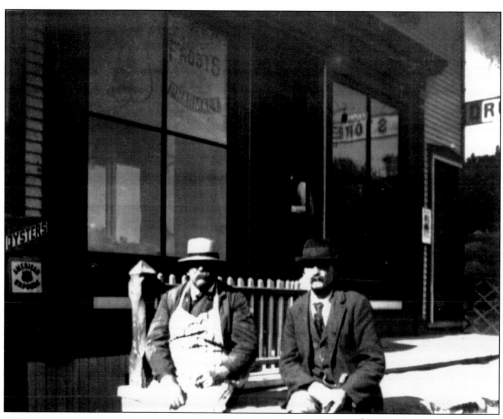

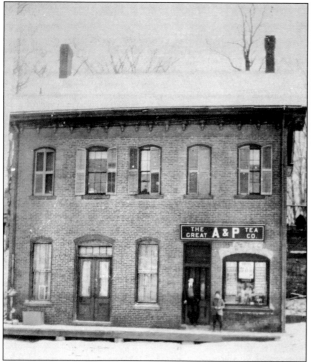

Around 1900, druggist E.A. Frost operated a pharmacy in the brick building that was formerly the O.G. Phelps store. Another pharmacist, J.S. Benham, advertised "Physician's Prescriptions Prepared Day or Night." Benham's pharmacy was located near the railroad depot and offered toiletries, candy, cigars, pipes, and tobacco, as well as a circulating library.

Joseph Clark constructed this two-and-a-half-story brick office building in the mid-1800s. The second floor was occupied by Clark's office and C.W. Withers law office. A number of businesses were located there over the years, including a Great Atlantic & Pacific Tea Company store (around 1920).

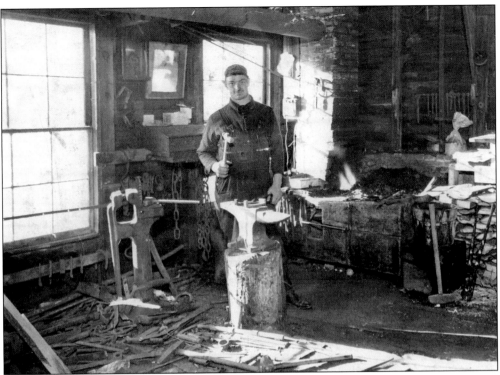

This blacksmith shop was located on upper Main Street near Kienle Road. With transportation by horse and buggy being the standard, blacksmiths were kept very busy, facing long hours molding metal over a hot fire. By the early 1900s, as the use of automobiles spread, the need for blacksmiths diminished.

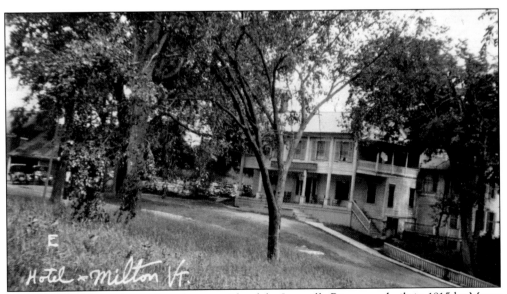

The Elm Tree House, located on the west side of the Lamoille River, was built in 1815 by Moses Ayres. Charles Skeels, a local hotel proprietor, purchased the structure and renamed it the Skeels Hotel.

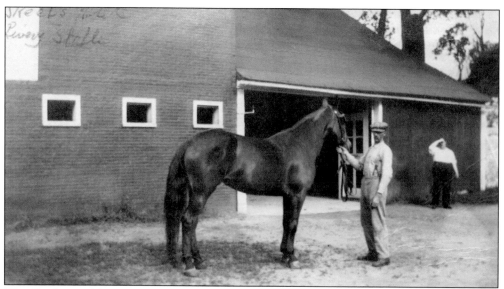

The Skeels Hotel kept a livery stable for its customers. Before automobiles, a horse and buggy were the only way for most people to get around. Skeels could provide horses and carriages for his customers to travel the dirt roads of Milton.

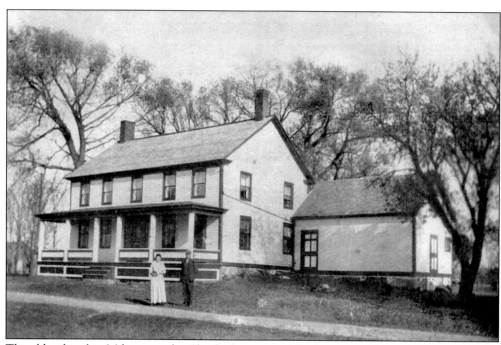

The oldest hotel in Milton was the Checkerberry Hotel, built around 1800. Also known as "the Rest," it was located at the site where the stagecoach line went through. The former hotel is now a private residence.

Pictured here is an early telephone in Milton. Joel Farnsworth, who lived near Cobble Hill in Milton, developed an interest in telephones during the 1880s and began making his own. He later created the Farnsworth Phone Company. The Milton Historical Society obtained this telephone at an auction in 2007.

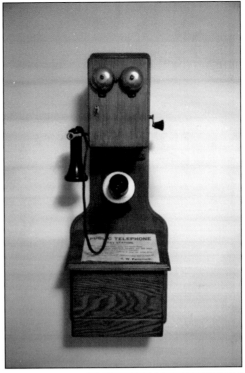

The G.W. Phelps store was located near the bridge over the Lamoille River in Milton Falls and carried a wide variety of items. There was a lively competition in the late 1800s and early 1900s between the merchants located near the bridge (like G.W. Phelps) and those located near the railroad depot.

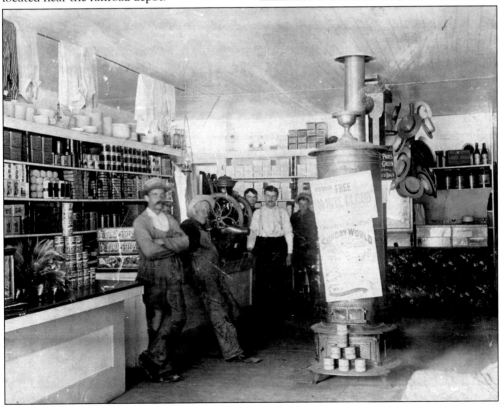

Noted photographer J.K. Smith settled in Milton and ran a studio on what is now School Street, and, later, at the Skeels Hotel. Many of the photographs in this book were taken by him. Smith's many pictures have done much to help preserve Milton's history.

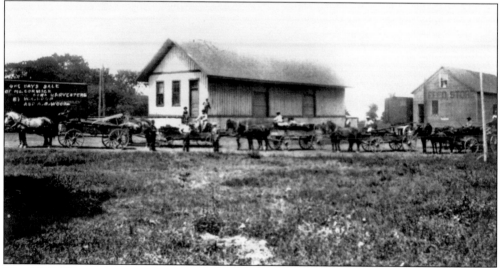

The Main Street area was divided into two distinct business districts—lower Main Street and upper Main Street. Here, farmers line up at the feed store on upper Main Street near the railroad depot.

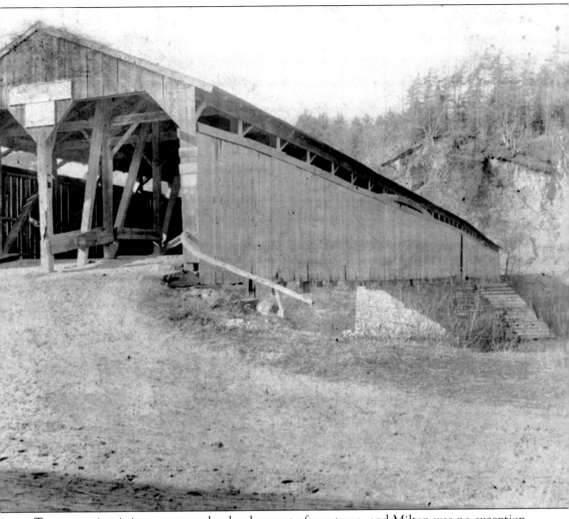

Transportation is important to the development of any town, and Milton was no exception. According to records, West Milton was the first part of Milton to be settled, and this covered bridge over the Lamoille allowed residents and businesses in the thriving community stay connected. Built in 1835, the 325-foot-long structure was the third bridge to be built across the Lamoille in West Milton. One earlier bridge was located slightly downriver, and another crossed slightly above. In the area near this bridge, a number of businesses were started, including a store on what became known as the Costello property, and a creamery on the property of Eugene Towne. A church was built at the top of the hill across the bridge, and the hill became known as Meeting House Hill. The bridge was destroyed on March 2, 1902, by high water and ice.

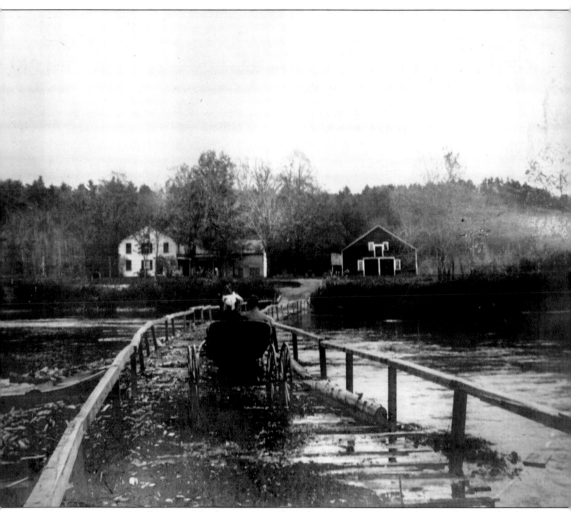

During a 1902 flood, ice and high water combined to weaken the structure of the bridge until it finally collapsed. To maintain some connections between friends and businesses, a temporary floating bridge was installed at the site.

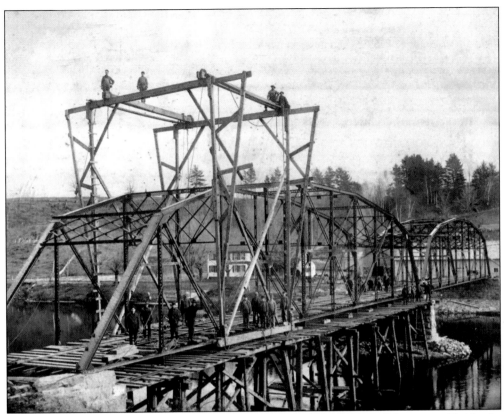

A one-lane truss bridge was constructed a little upstream from the site of the covered bridge by the United Construction Company of Albany. Truss bridges—which took their name from their triangular sections, or trusses—were a common type of bridge from the 1870s until the 1930s.

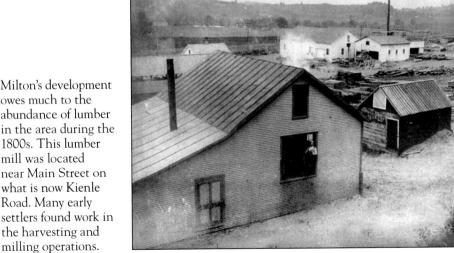

Milton's development owes much to the abundance of lumber in the area during the 1800s. This lumber mill was located near Main Street on what is now Kienle Road. Many early settlers found work in the harvesting and milling operations.

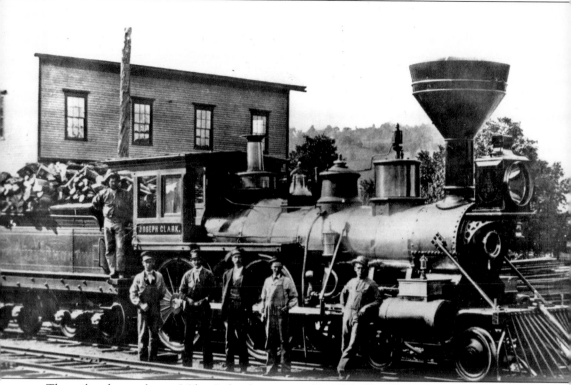

The railroad was a key to Milton's development in the 1800s. Joseph Clark was instrumental in bringing the railroad to Milton. This engine was manufactured in 1849 and was one of the earliest produced by the Baldwin Locomotive Company in Philadelphia. Originally named the *Governor Paine*, the engine was renamed *Joseph Clark* in 1869.

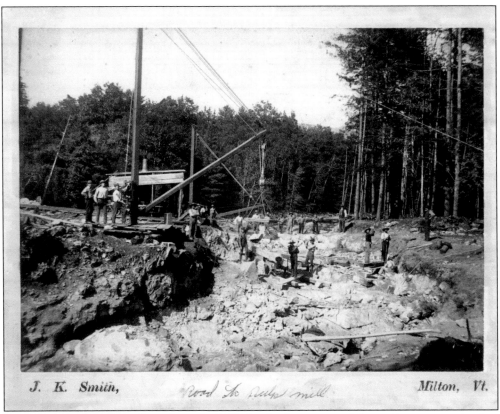

J. K. Smith, *Road to pulp mill* Milton, Vt.

Construction of a pulp mill in the early 1800s by the International Paper Company at the foot of the Great Falls required that a road (present-day Ritchie Avenue) be built to the site. The construction crew pictured here is clearing the land for this purpose.

In this picture, a crew begins to move a large part of the penstock into place. A penstock is a sluice or a pipe that delivers water to a waterwheel or turbine. The idea for penstocks developed with the waterwheel and was applied to later systems.

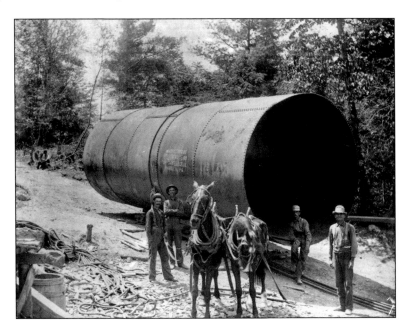

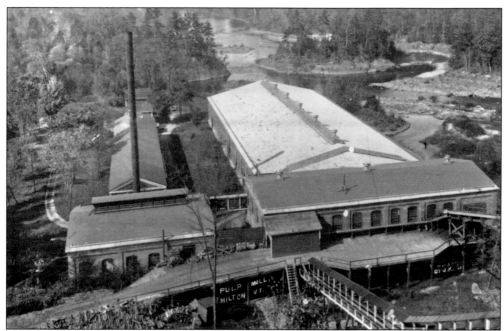

The completed pulp mill, seen here, brought a great deal of prosperity to Milton. It employed as many as 100 men during its busy winter season, and many of these men sought housing in the area around Main and River Streets and shopped in the stores of Milton.

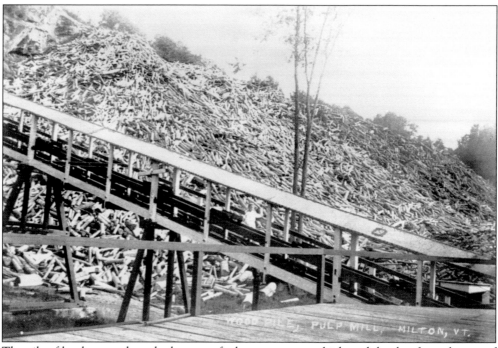

The pile of lumber stands at the bottom of a long conveyor, which took lumber from the top of the hill on Route 7 down to the mill. A railroad spur, which ran from the station and paralleled what is now Mackey Street, brought 10 to sometimes more than 40 loads of pulpwood a day.

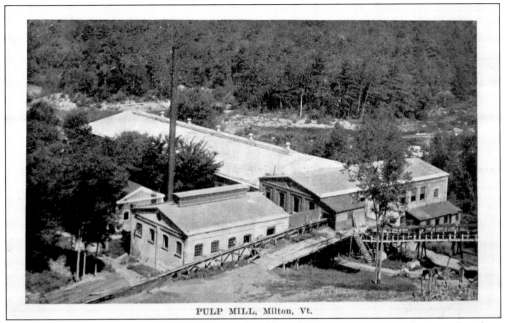

PULP MILL, Milton, Vt.

This is another view of the completed pulp mill. Although prosperous in its early years, the plant shut down during a strike in 1925 and never reopened.

Milton has had a number of locations for its post office. The first post office was established in town in 1808. The one pictured here was located on River Street.

This building, located on River Street, housed Powell's store and the post office. It changed purposes over the years, but remained an important focus for commercial activity in the village.

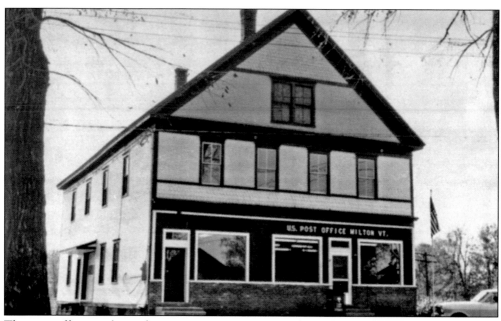

This post office was located on upper Main Street. Rural free delivery (RFD) of mail began in Milton in 1901. The idea for delivery of mail to rural areas is believed to have originated by the National Grange operation. The Post Office Department first experimented with the idea in 1891, and it quickly spread.

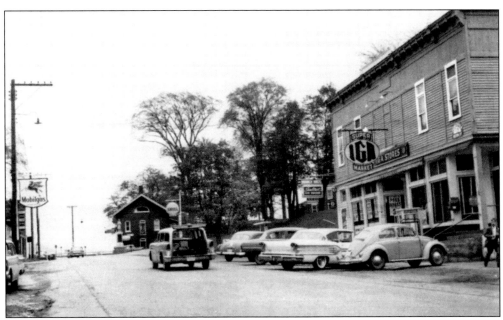

By today's standards, a store such as Branch's, pictured here, might seem antiquated. For the people of the time, though, Branch's provided a convenient place to shop for necessities. The Branch store was affiliated with the Independent Grocers Alliance (IGA), which began in 1926 as an effort to bring together family owned groceries in an alliance in the face of increasing competition from chain stores.

There were no churches in Milton in the early 1800s, but a number were built within a short time. This is the West Milton Church, near the West Milton Cemetery. For people living in remote West Milton, the church provided a center for spiritual and social events.

From the early to mid-1800s, Catholics in Milton Falls were visited occasionally by priests from Burlington. Toward the late 1850s, the bishop of Burlington proposed to build a Catholic church in Milton, and St. Ann's opened in 1859. The original structure was destroyed by fire, and the church pictured here was built in 1894 to replace it.

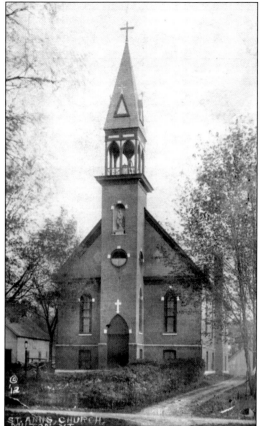

The residents of Miltonboro had their own Methodist church, pictured here, for many years. Built in 1860 at a cost of $2,000, the structure was capable of seating 300 people. The church was eventually dismantled, and the pulpit, pews, hymnals, and other artifacts were placed in a brick church at the Shelburne Museum.

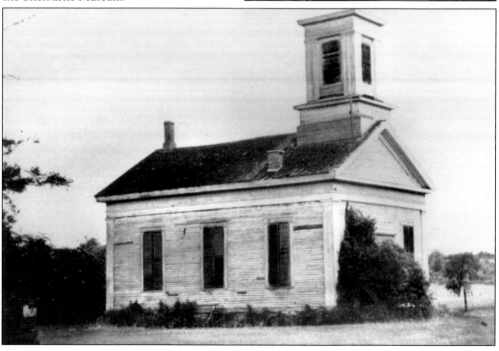

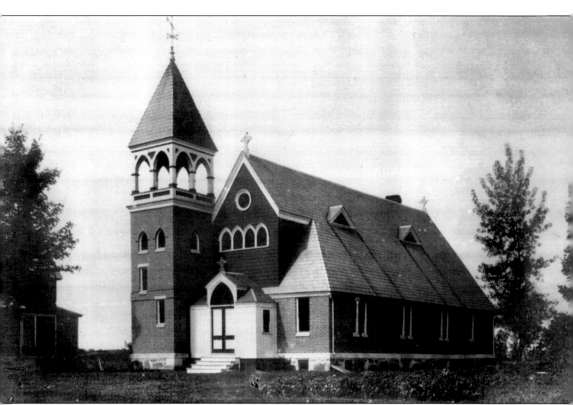

In the winter of 1831, the Trinity Episcopal Church was formed. Services were held at various locations until the late 1800s, when this church was built. The building is now the home of the Milton Historical Museum.

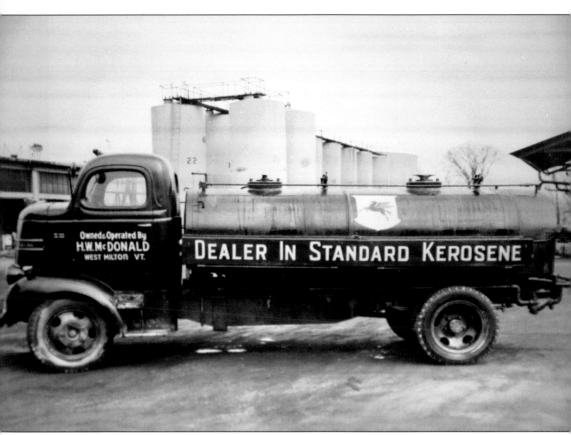

H.W. McDonald operated a fuel oil business in West Milton. It was one of many businesses established to serve a growing community. By the mid-1900s, many residents sought the convenience of oil despite its higher cost over other forms of energy.

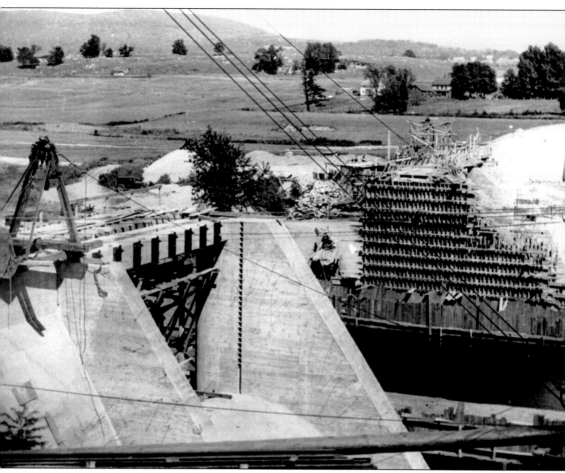

In 1936, the Public Electric Light Company began construction of a dam at Clark's Falls across the Lamoille River. After the devastating flood of 1927, the dam could control the Lamoille while providing a needed source of power. The dam would form the 750-acre Lake Arrowhead, which backed up three miles to the Georgia High Bridge. The highway north of the village had to be relocated at an estimated cost of $100,000, and several homes and businesses were also moved. Construction of the dam provided many needed jobs for workers.

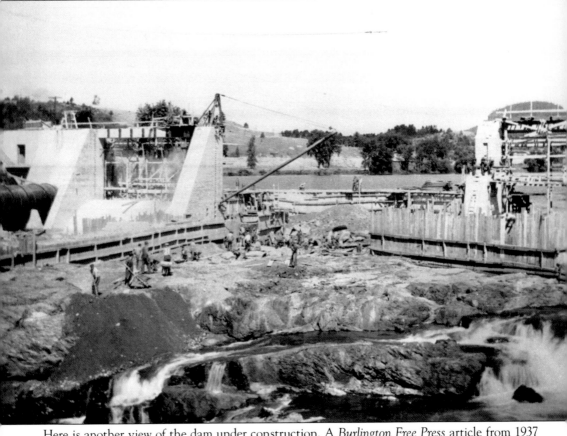

Here is another view of the dam under construction. A *Burlington Free Press* article from 1937 reports that the lake created by the dam was practically three miles long and one half mile wide. At a cost of well over half a million dollars, the project employed hundreds of men at a time when jobs were desperately needed. Another newspaper report notes the project "embodies the most advanced and skilful features known to engineering and construction science."

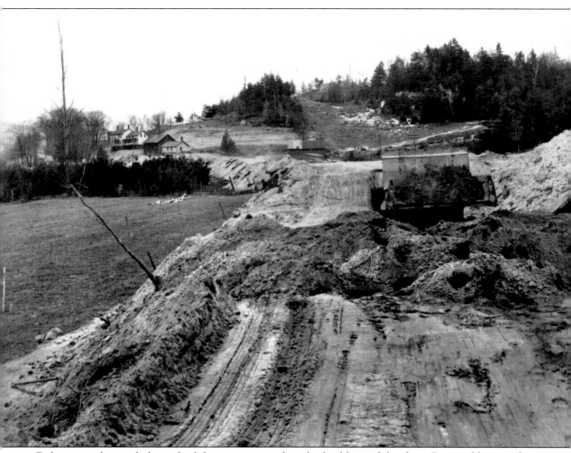

Relocating the road along the lake was essential to the building of the dam. Pictured here is the new road under construction.

NAMING THE NEW LAKE

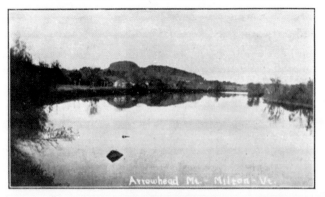

Arrowhead Mt. - Milton - Vt.

Longtime Milton resident and doctor Luman Holcombe suggested the name for the lake created by the dam, as seen in this letter to the *Burlington Free Press*. The name Lake Arrowhead was officially adopted, and, as the mountain is a natural geographic feature of the area, the lake became an important man-made feature of the local geography.

To the Editor of the Free Press:

The St. Albans Messenger article entitled "A New Lake" which was published Tuesday in The Broadcaster, asks "What is the name of the new lake going to be?" The Messenger vividly portrays what will surely be

"A vision of beauty that charms the eye
When the lure of the city fails."

Refreshing as a mountain stream is the mere suggestion of mountains or lakes.

As this new lake will lie along the foot of Arrowhead Mountain, rich in Indian lore and relics, reflecting as a mirror its clear cut sylvan beauty, would not the name Arrowhead Mountain Lake be appropriate and attractive?

L. C. HOLCOMBE, M. D.
Milton, Vermont, February 18, 1937.

In 1946, downriver from the dam at Milton Falls, the Public Electric Light Company began construction of a dam at this site, near the lower falls in Milton. Amos Mansfield, one of the town's first settlers, built the first sawmill in 1789 near the site of the Petersen Dam.

The Peterson Station Dam was built at a cost of more than $1.3 million. When completed in 1948, it flooded 136 acres of land. The construction of dams on a river like the Lamoille is not always popular with sport fishermen. In the 1990s, there was talk of removing the Petersen Dam, but it still stands today.

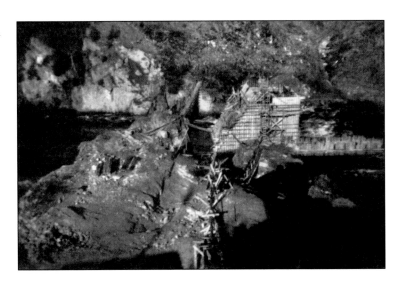

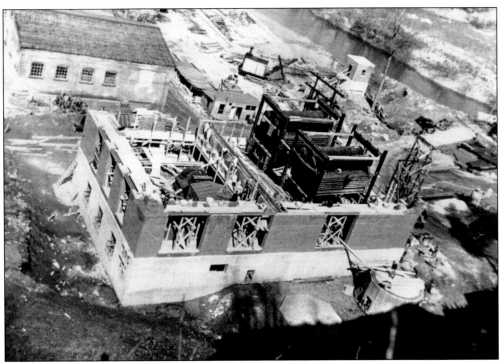

The Public Electric Light Company began constructing a power plant below the dam at Milton Falls at a site previously occupied by a pulp mill operated by the International Paper Company. The pulp mill was dismantled after sustaining heavy damage in the flood of 1927, and construction on the power plant was begun in 1929.

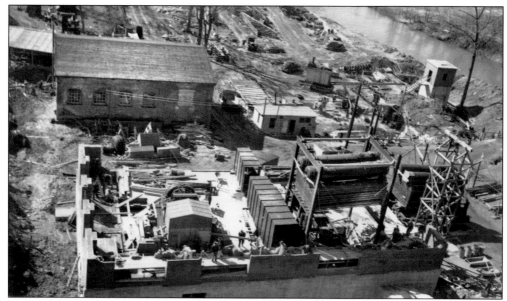

Demand for power was growing in the 1930s, and hydroelectricity was considered clean and efficient. When the station first opened, it provided for one generator of 3,000 kilowatts per hour. By 1937, the capacity had doubled.

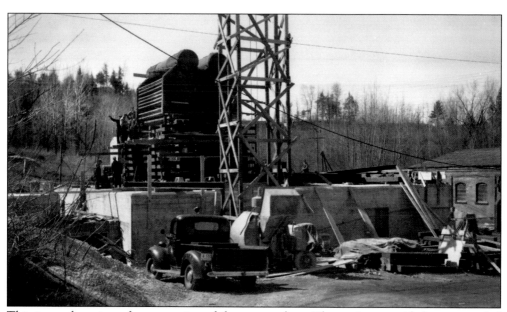

This is another view of construction of the power plant. The project provided many needed jobs to workers in the area, and demand for electricity continued to grow rapidly in the 1930s and 1940s.

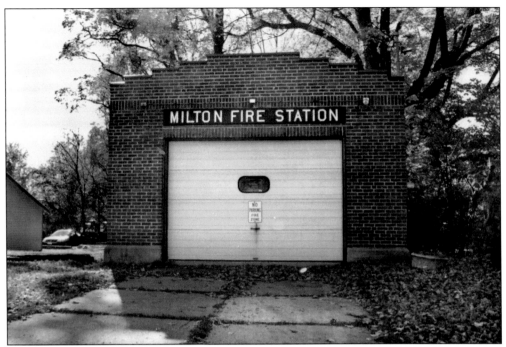

Milton's fire department was organized in 1937, and its first chief was George Allen. Pictured here is the first fire station, built on land donated by Ellen Miller. It still stands today near the village cemetery on Main Street. In 1966, the town's firemen started an ambulance service.

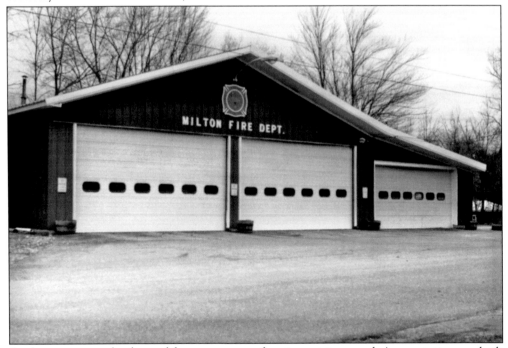

As the town grew, the demand for newer types of equipment increased. A new station was built in 1965 on Kienle Road. It served the town into the mid-1990s, when a modern station was built to house the fire and rescue squads on Bombardier Road.

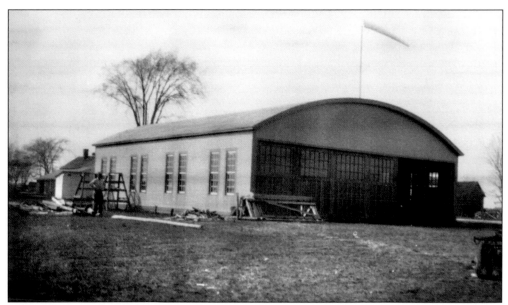

One of the more interesting businesses in Milton's history is Schill's Airport. Aviation enthusiast Paul Schill established an airport on a level plot of land along what is now Route 7. He and his son Henry cleared the land that stretched from the current Sears store all the way to Middle Road.

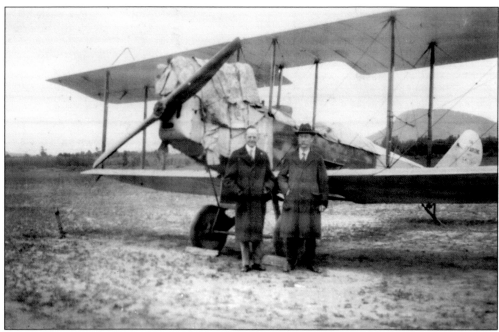

Pictured here at Schill's Airport, with Cobble Hill in the background, are Alfred Heininger (left) and Professor Rehder. Heininger was a Burlington businessman who provided financial support for Schill's Airport and, with others, contributed to the Vermont Air Transport Company, which was formed in 1922.

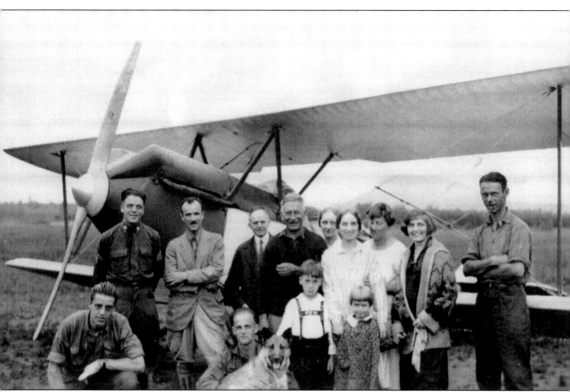

Paul Schill stands to the far right in this 1926 photograph at the airport. He had hoped to create an airplane-manufacturing operation, but investors began to decline in the 1930s. In the early 1930s, a ballroom dance floor was laid in the hangar. Among the events hosted there were marathon dances, a popular form of entertainment during the Depression.

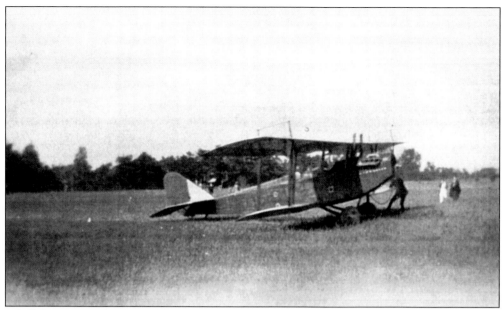

Schill first acquired two World War I surplus "Jennys," as the planes were known. Flights were available to the public for a fee of $5, or, for a shorter ride, passengers could pay $1.50. Schill opened a flight school and began to work on a new type of plane at his Milton airfield.

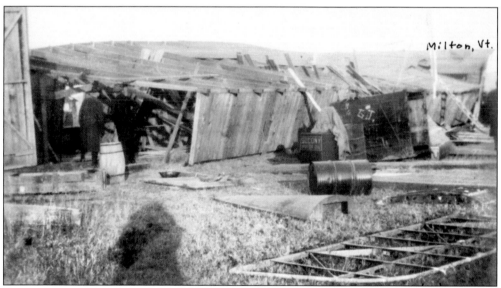

One goal of Paul Schill was to put Milton on the map as an airplane-manufacturing center. He enjoyed experimentation, and even developed a design for a motor-glider type of airplane. The craft would be a low-winged airplane and would use motor power to get in the air, where it would glide until using gasoline to gain more altitude. Unfortunately, before he had a chance to test his design, a severe windstorm collapsed the hangar (pictured here), and the plane was ruined.

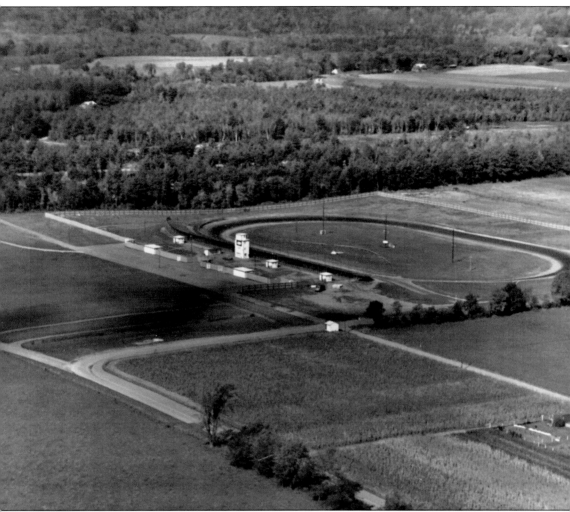

In the early 1960s, Kenneth Squier, a radio announcer from WDEV in Waterbury, and several Milton residents developed plans for a racetrack in Milton. The track, built to NASCAR specifications, opened on June 1, 1965. At the dedication ceremonies, that year's Miss Vermont (Milton High School graduate Lois Dodge) made an appearance. Catamount Stadium had seats for 6,500 people and, for the time, was considered to have state-of-the-art lighting. The control tower was four stories high. On any Saturday night in the summer, a large crowd would be in attendance.

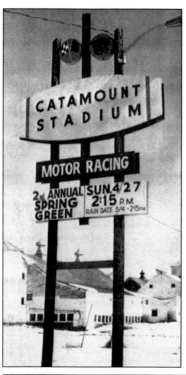

The Catamount Stadium was built on the property of the Kermit Bushey Farm. Some of the farm buildings can be seen in the background of this sign. Racing was popular in Milton, but over time, the cost of maintaining automobiles grew increasingly prohibitive.

In the 1950s, young people would often find isolated stretches of road and engage in drag racing. In 1963, the owners of B & M Motors, Herbert McCormack and Maurice Bousquet, decided to finance the construction of a quarter-mile-long drag strip on Route 7, near the West Milton Road. The track existed only briefly because of the prohibitive cost of resurfacing.

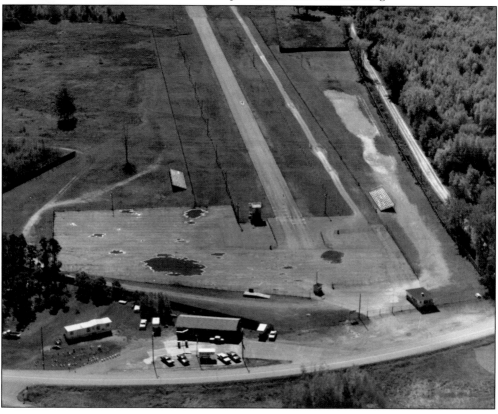

Glen Bushey purchased the former Rex Hawley filling station in 1968. An addition to the building was constructed, and Glen's sub shop opened. In 1968, the property was purchased by the Rene Bilodeau family and began operating as Rene's Discount Beverage & Deli.

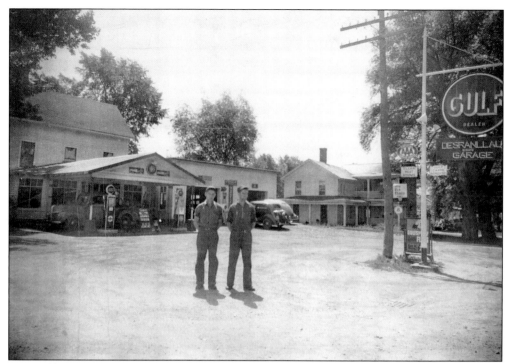

Pictured here are Emile and Jean Desranleau, who started Desranleau Brothers Garage on River Street in 1938. The two brothers ran the garage for over 40 years. Emile was a 1947 graduate of the Kaiser & Frazer Motor Cars Service and Sales School at Willow Run, Michigan, and a Kaiser & Frazer dealer in Milton. He maintained all of the town's highway equipment from 1947 to 1970.

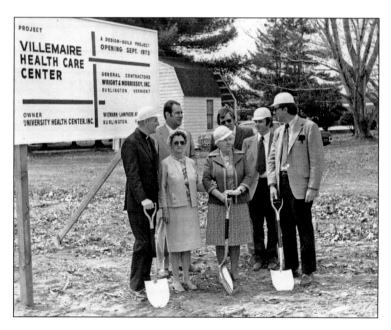

To serve the area's growing population, Milton was chosen as the site of a regional health care facility in 1972. Construction began at the site on Villemaire Lane near the high school, and on October 7, 1973, the health center opened. This picture shows the groundbreaking ceremony.

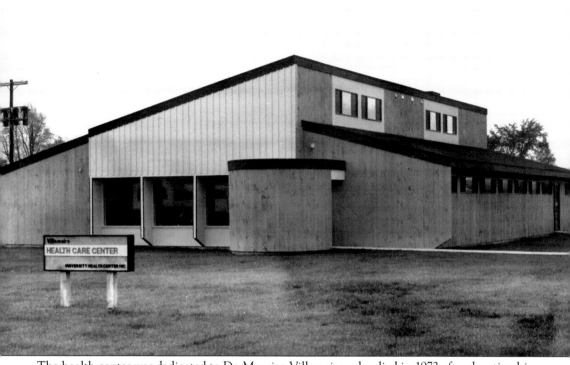

The health center was dedicated to Dr. Maurice Villemaire, who died in 1972 after devoting his life to the medical care of the people of Milton.

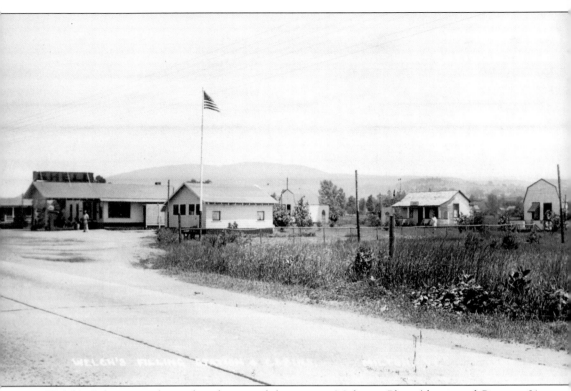

Welch's Cabins were located at the site of the present Midtown Plaza (the site of Century 21 Real Estate, the Lucky Wok restaurant, and more) Walter and Mary Welch opened the business in 1931. The business encompassed a Shell gas station, garage, automobile supply store, several cabins, a store, and a restaurant. In the 1950s, it was owned by the Conklin family; it was later owned by the Lambert family.

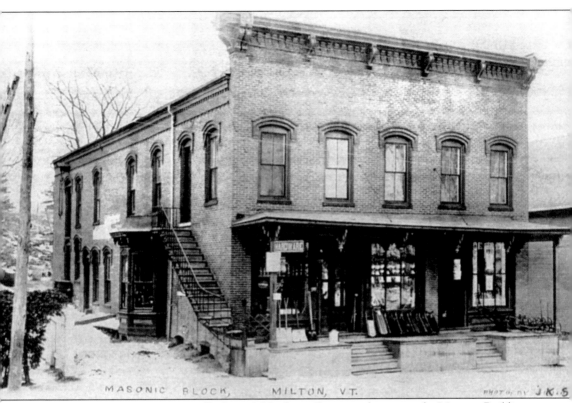

MASONIC BLOCK, MILTON, VT. PHOTO BY J.K.S

This large brick structure, originally Quinn's Hardware Store, was known as the Masonic Building. It was located at the site of the original town house, which had been built in 1849. Fire was a constant danger for old buildings, and this one burned in the late 1800s.

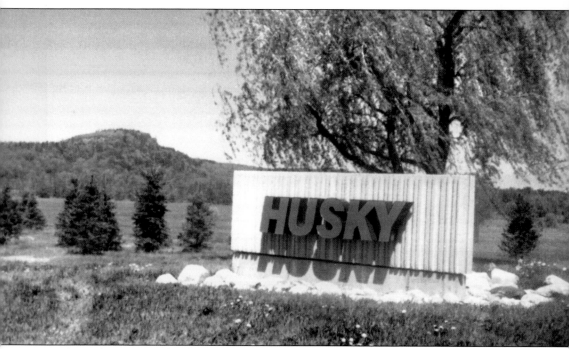

In the mid-1990s, another large company came to Milton. After competing with a number of other communities, Milton became the site of a manufacturing facility of the Husky Injection Molding Company of Canada. The company purchased the Devino Farm on North Road, and construction began shortly thereafter.

Six

DISASTERS

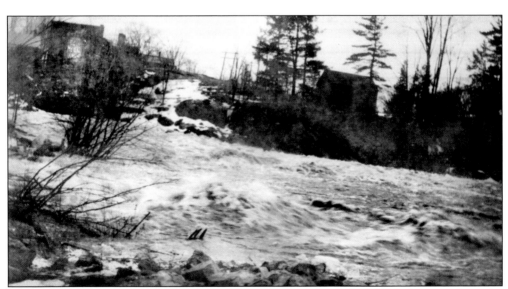

The rivers of Vermont have been known to cause flooding, and in 1902, the area along the Lamoille River in West Milton was hit hard, as seen in this photograph. The covered bridge was destroyed, and residents were cut off from the south side of the river until a temporary structure was built.

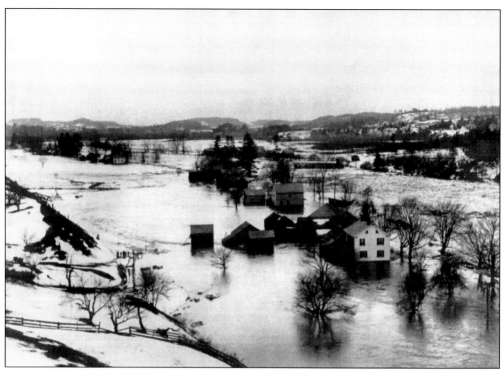

This is another photograph from the 1902 flood. Unfortunately, the rivers of Vermont were susceptible to flooding because of swelling caused by the springtime runoff from the mountains. Ice jams sometimes caused the water to back up and overflow the banks, and a quick snowmelt and rain could create flooding conditions as well.

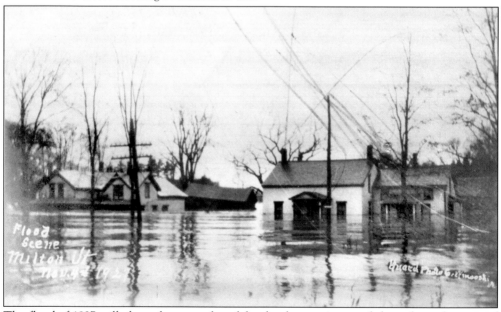

The flood of 1927 will always be remembered for the damage it caused throughout the state of Vermont. Any community near a river suffered catastrophic results, and Milton was no exception. This picture, taken near River Street, shows the extent of the flooding.

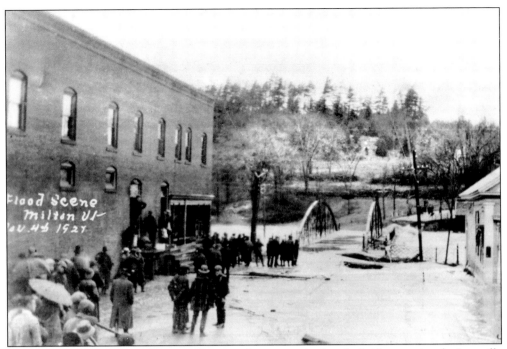

As the water rose on November 4, 1927, it was almost certain that the bridge crossing the Lamoille would not survive. This photograph shows the rising water shortly before the bridge was washed away. Witnesses gathered to watch the event.

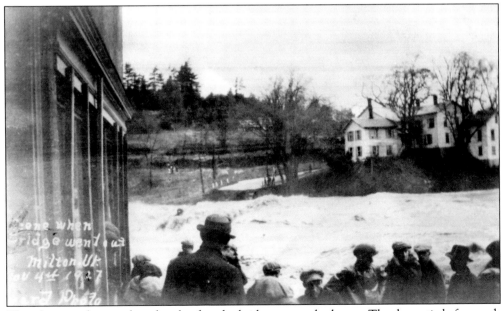

This photograph was taken shortly after the bridge was washed away. The dramatic before-and-after pictures of the bridge and its absence demonstrate the full fury of the flood of 1927.

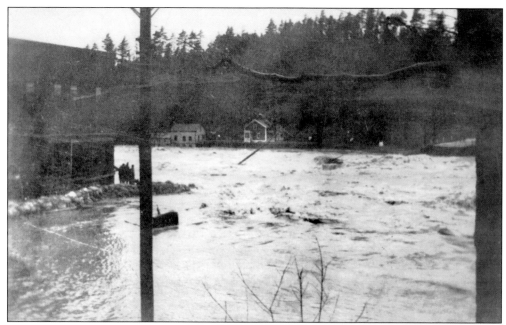

The rain began on November 3, 1927, and continued for hours. As the rain fell and the water rose, it became apparent that the potential for catastrophe was great. Throughout Vermont, rivers rose and eventually overflowed their banks, causing terrible damage.

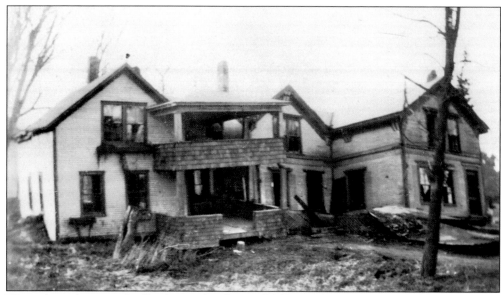

Throughout the state, the flood caused millions of dollars of damage, and residents were in for a hard winter. In addition to the bridge, the flood carried away numerous buildings including the Star Theater, the wheelwright shop of H.C. Bevins, and Kennedy's Store.

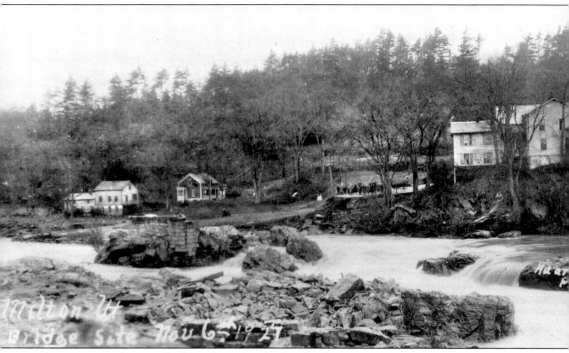

This scene was photographed two days after the flood as the waters receded. It shows what remains of the bridge over the Lamoille River. Even two days later, the water level is still high, hampering cleanup efforts in Milton and elsewhere.

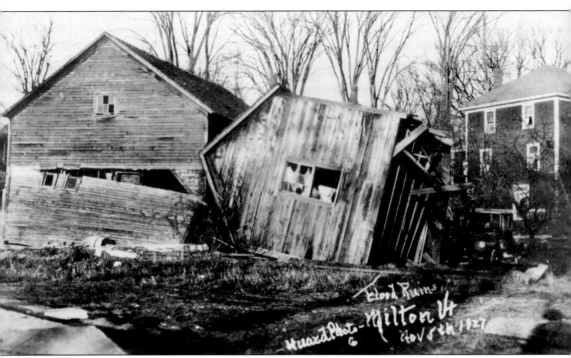

Many businesses would not recover from the flood, and the area of Milton Falls, though rebuilt, would be forever changed. Many families who lived in the River Street area lost everything. Soon after the disaster, the Red Cross reached Milton to assist in the recovery. Coming as it did only about two years before the stock market crash of 1929, the flood of 1927 had a lasting impact on the area.

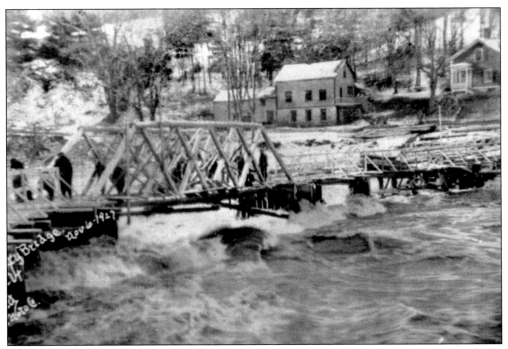

The job of rebuilding began almost immediately, and this temporary bridge was constructed over the Lamoille River.

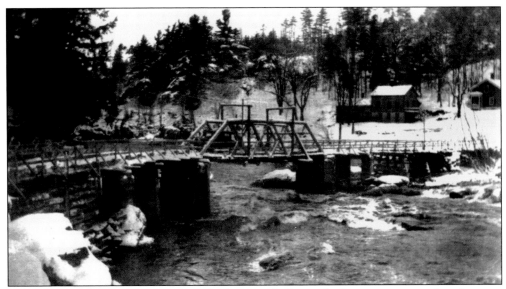

Here is another view of the temporary bridge over the Lamoille. It was imperative that the town be reunited so that some sense of normalcy could return.

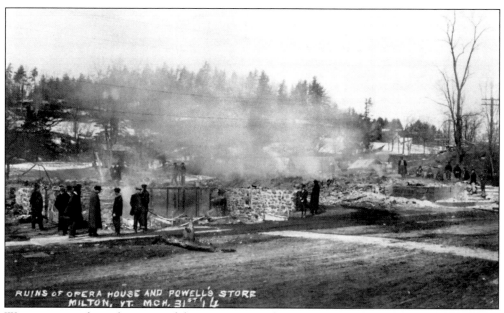

Water was not the only source of destruction in Milton. On March 31, 1914, the Opera House burned, along with a number of neighboring buildings.

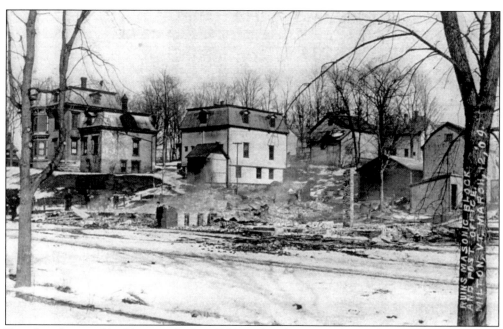

Fire often destroyed buildings in the late 1800s and early 1900s. The combination of wood-frame buildings and wood as a source of fuel for heat could create dangerous conditions. The Masonic Block was destroyed in this fire in the early 1900s.

In February 1943, the high school caught fire. All 200 students escaped within minutes unharmed, but a custodian did suffer injuries trying to put out the blaze.

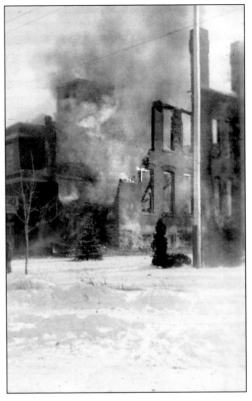

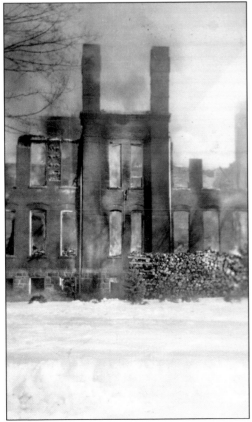

Pictured here is another view of the high school fire. The fire department was hindered in its effort to fight the blaze by the subzero temperatures and frozen waterlines, and crews from Colchester and other towns arrived to assist Milton's department.

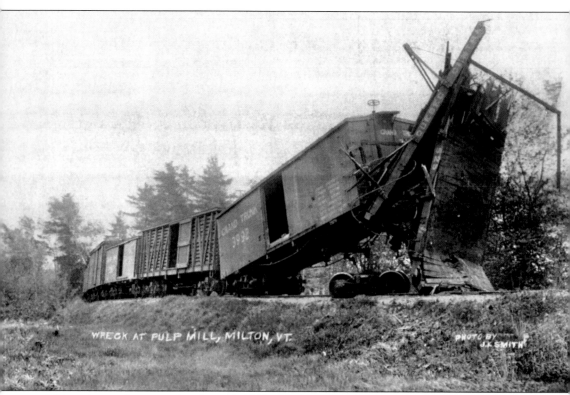

WRECK AT PULP MILL, MILTON, VT.

PHOTO BY
J. K. SMITH

This train wreck occurred in the early 1920s on the rail line leading to the pulp mill. It is unclear how the two trains managed to collide. The rail line from the main branch went along a right-of-way near present-day Mackay Street.

Seven

PEOPLE

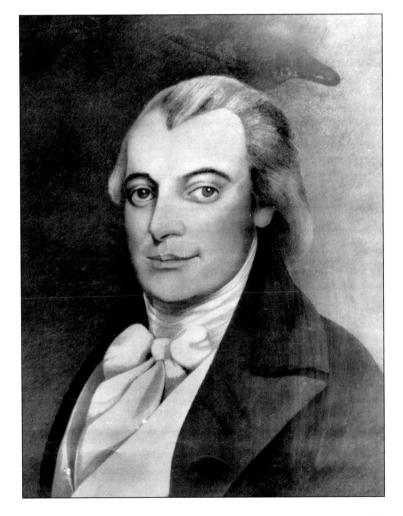

Noah Smith was influential in the development of Milton. He moderated one of the first proprietors' meetings, held in 1788 in Manchester. He owned nearly all of the land in the village and, though a lawyer by training, built two sawmills and a gristmill. He eventually donated the land that now makes up Main Street. Smith is buried in the Milton Village Cemetery.

Joseph Clark was instrumental in the development of Milton in the 1800s. He and his partner, Joseph Boardman, hired crews of men to cut lumber in West Milton. The logs were floated on Lake Champlain to Montreal before being sent on to England. Clark settled in Milton Falls, and his house still stands today. He developed a number of business interests, including a sawmill and a gristmill, and was also a director of the Vermont Central Railroad. He was actively involved in bringing the railroad through Milton.

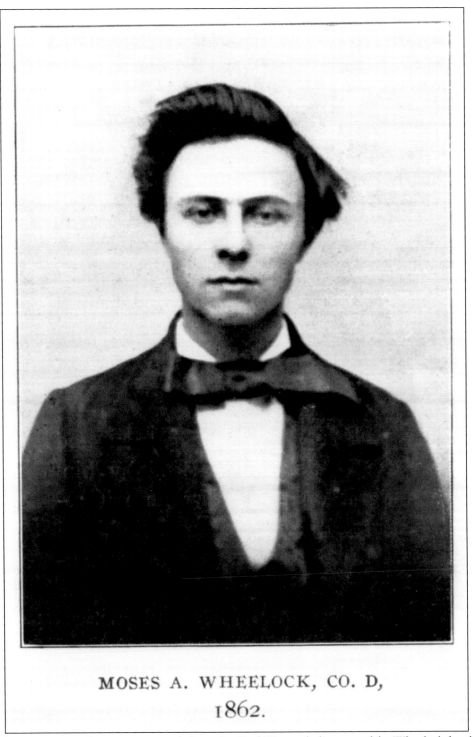

MOSES A. WHEELOCK, CO. D,
1862.

Milton sent many of its young men to fight in the Civil War, including two of the Wheelock family's thirteen children. Moses enlisted, along with his brother John, on September 6, 1862. He left the army in July 1863 and died a few days after reaching home, having been sick with a fever.

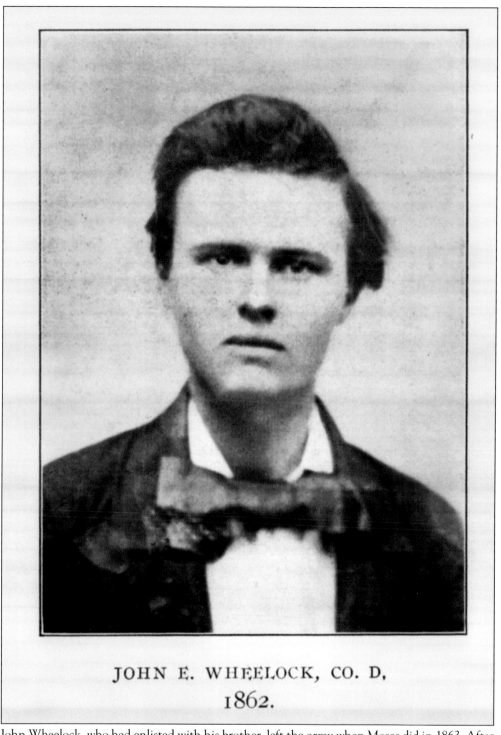

JOHN E. WHEELOCK, CO. D,
1862.

John Wheelock, who had enlisted with his brother, left the army when Moses did in 1863. After his brother's death, he reenlisted with the 8th Vermont Cavalry. He later became a lawyer and, eventually, principal of Milton High School.

Henry O. Clark was born in Milton in 1844 and graduated from college in Buffalo. He was working in Chicago when Lincoln appealed for more soldiers in 1862. Clark came home to Milton to enlist and was appointed to be a recruiting officer. He was responsible for enlisting a good part of Company D of the Vermont Regiment.

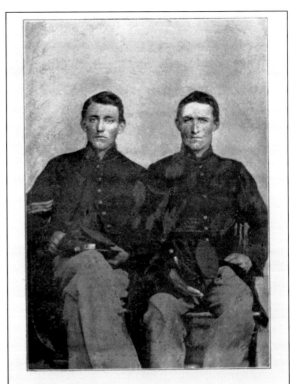

SERGT. HENRY O. CLARK, CO. D,
1862.
Clark on the left; John Welch of Co. I on the right.

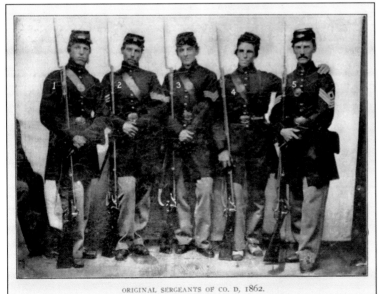

ORIGINAL SERGEANTS OF CO. D, 1862.

No. 1. Marquis F. Marrs. No. 2. Julius F. Densmore.
No. 3. Henry O. Clark. No. 4. George Stevens. No. 5. William L. Blake.

Three of the men in this photograph—Marquis Marrs (far left), Henry O. Clark (center), and William Blake (far right)—came from Milton. Julius Densmore (second from left) and George Stevens (second from right) were from Colchester. Many of the Company D, 13th Regiment came from Colchester, but Milton had its share of representation.

115

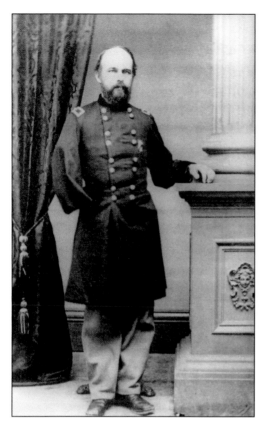

Gen. George Jerrison Stannard was born in Georgia, Vermont, but built a home in Milton after the Civil War. He was considered an excellent leader and was twice seriously wounded. His second injury, which occurred at Pickett's Charge, required the amputation of his right arm, and he designed his barn in Milton to accommodate a one-armed man.

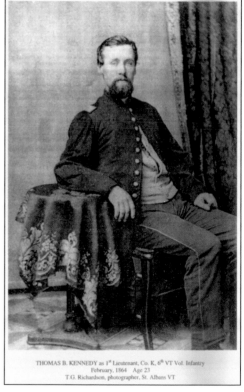

THOMAS B. KENNEDY as 1ˢᵗ Lieutenant, Co. K, 6ᵗʰ VT Vol. Infantry
February, 1864 Age 23
T.G. Richardson, photographer, St. Albans VT

Thomas Kennedy was born in Milton on August 20, 1840, the 11th of 15 children. Despite his young age, he proved to be a good leader and was promoted to captain and then first lieutenant of the 6th Vermont. His company saw such heavy fighting that only 18 of the original 97 members returned alive and unwounded.

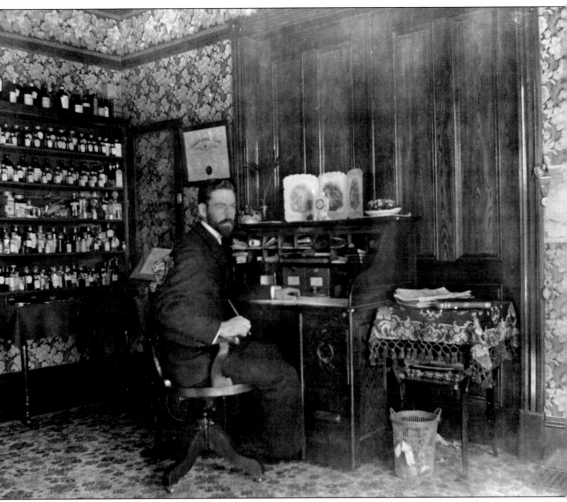

Dr. Luman Holcombe is pictured here in his office. A graduate of the University of Vermont Medical School, Dr. Holcombe established a practice in Milton in 1894. He became somewhat famous after delivering a baby born about 100 days prematurely. The baby weighed one and a half pounds, and Holcombe fashioned an incubator from a shoebox and later had a wooden incubator made. The baby survived and lived a long life.

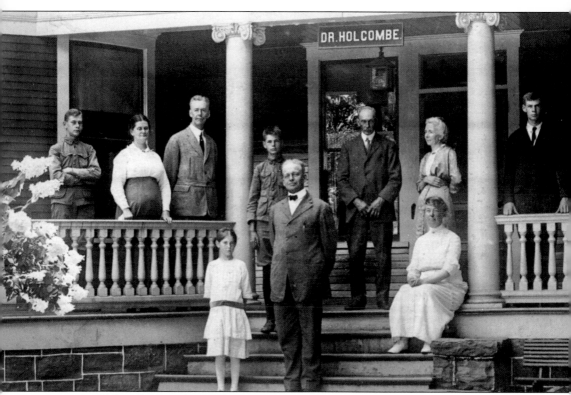

Here, Dr. Holcombe (standing in front) poses with his family of the porch of his house on Main Street. His stylish home still stands today. In those days, a doctor could be called at any time of the day or night, and Holcombe appears to have been a prosperous and well-respected physician and member of the community.

J.K. Smith was a well-known photographer in the late 1800s and early 1900s. He had a studio on School Street and later near the Skeels Hotel. In addition to taking popular photographs of individuals, he also strove to record events as they happened.

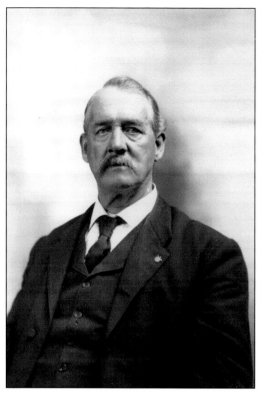

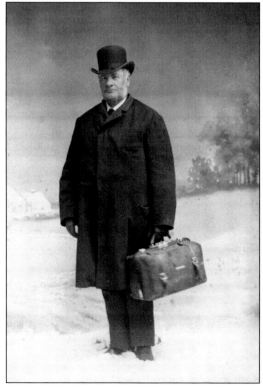

Pictured here looking every bit like a country doctor, Lucious J. Dixon graduated from the University of Vermont's College of Medicine in 1858. He eventually settled in Milton and went on to become one of the most well-known and respected general practitioners in Vermont.

Dr. Irving Coburn graduated from the Baltimore Medical College in 1901 and took over Dr. Dixon's practice after the latter's death in 1902. He was elected to the Vermont House of Representatives in 1912 and became a Chittenden County senator in 1921.

E.T. Holbrook, pictured here at his desk, was town clerk in the late 1800s. The work of the town clerk helps keep the day-to-day business of the town functioning. This may mean keeping records, overseeing elections, and issuing permits, among other responsibilities.

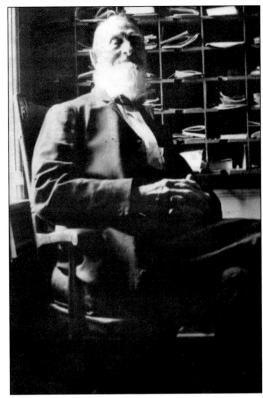

Homer Powell is pictured here with his wife and children. In its history, Milton has only had 14 town clerks, and Powell filled the role for many years.

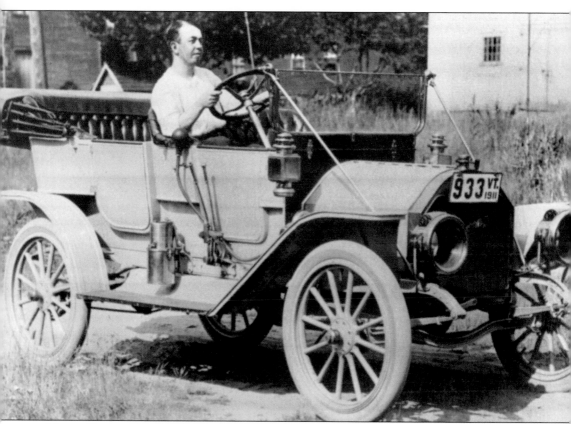

Hiram Skeels, son of hotel proprietor Charles Skeels, is pictured in 1911 driving Milton's first automobile. Roads in northern Vermont were not especially welcoming for automobiles, so driving could be somewhat of an adventure.

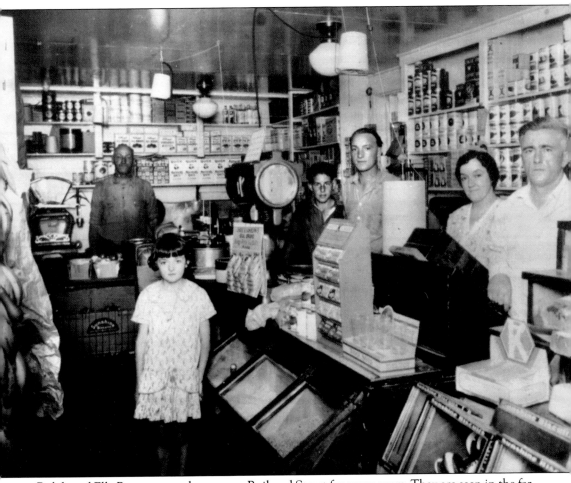

Ralph and Ella Ryan operated a store on Railroad Street for many years. They are seen in the far right of this photograph from around 1920, with their daughter Allison standing in the foreground. Also pictured are, from left to right, Dean Johnson, Allan Rouse, and Howard Johnson.

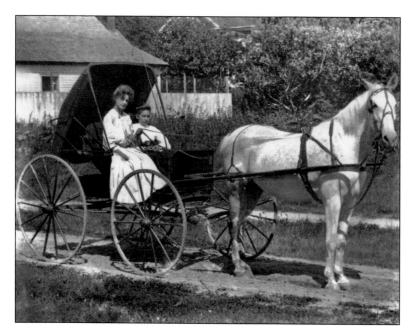

This photograph, taken on School Street, captures two women out for an afternoon horse-and-buggy ride. Photographs, like this one, of life on Main Street and in the surrounding area reflect a much slower pace than that of the community today.

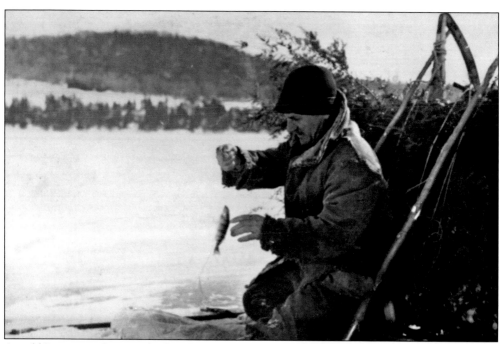

Arnold Beaupre is photographed ice fishing on Lake Arrowhead. Ice fishing is a popular activity in the winter months, and for sport fishermen in any season, Milton's proximity to Lake Champlain and the man-made Lake Arrowhead provide excellent opportunities.

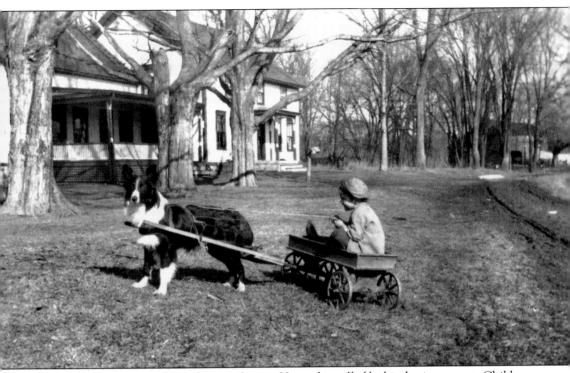

In this photograph from the early 1900s Lyman Howard is pulled by his dog in a wagon. Children and adults alike had to seek their own diversions.

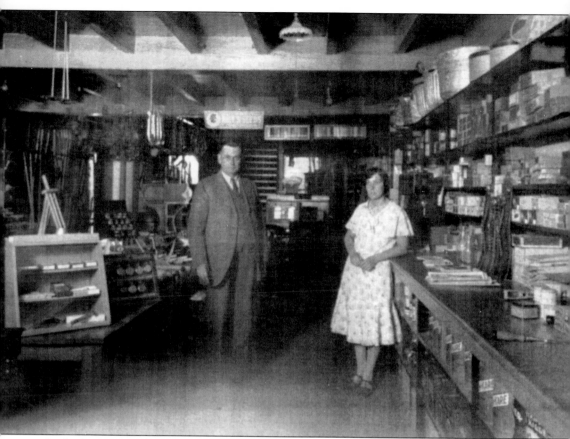

In the late 1800s, the Zebbie Wagner family acquired the store on upper Main Street that had originally been built by George Ashley. During the early 1900s, Zebbie's son Joseph E. Wagner purchased the store. In the picture, Joseph Wagner and employee Mildred Mayville await their next customers.

Pictured here are Orlow Sanderson and his son Loren. Orlow was the great-grandson of John Sanderson, one of the original farmers in Milton. In an increasingly mobile society, people may come and go from a community. However, Milton still has its share of residents who can trace their ancestry back 100 years or more, and the Sandersons are a good example of a family with deep roots in the community.

As in many small communities, people come together for many reasons. In this picture from 100 years ago, the Congregational Women's Association has gathered for a meeting and group photograph. One of the things that keep a community strong is the connection between people as they pursue common interests.

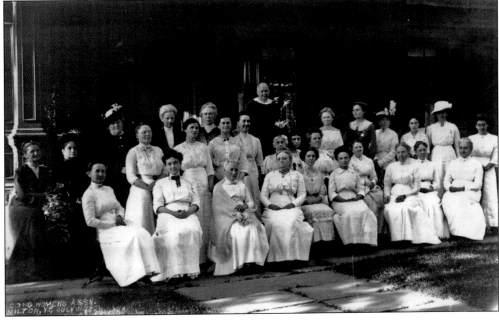

DISCOVER THOUSANDS OF LOCAL HISTORY BOOKS FEATURING MILLIONS OF VINTAGE IMAGES

Arcadia Publishing, the leading local history publisher in the United States, is committed to making history accessible and meaningful through publishing books that celebrate and preserve the heritage of America's people and places.

Find more books like this at
www.arcadiapublishing.com

Search for your hometown history, your old stomping grounds, and even your favorite sports team.

Consistent with our mission to preserve history on a local level, this book was printed in South Carolina on American-made paper and manufactured entirely in the United States. Products carrying the accredited Forest Stewardship Council (FSC) label are printed on 100 percent FSC-certified paper.

MADE IN THE USA